CHÁVEZ RAVINE, 1949

A Los Angeles Story

CHÁVEZ RA

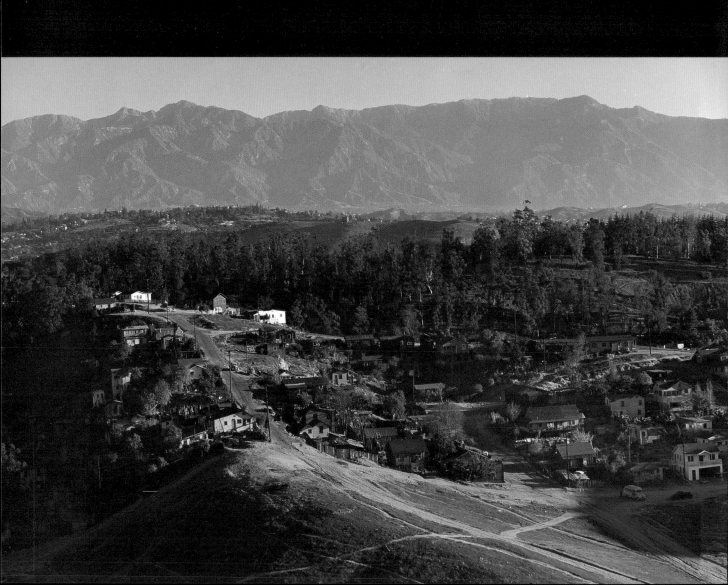

VINE, 1949

A Los Angeles Story

Don Normark

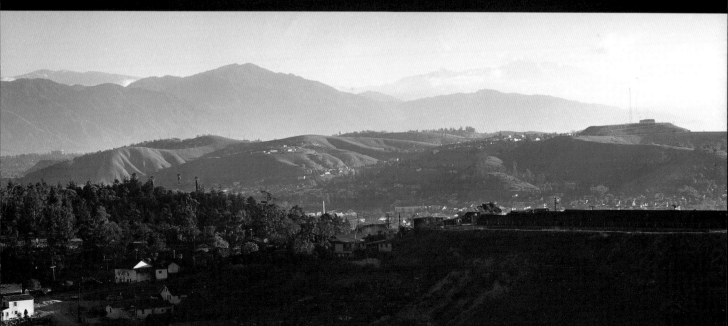

Library of Congress Cataloging-in-Publication Data available.

ISBN 0-8118-2534-5

Printed in Hong Kong

Designed by Frances Baca

Distributed in Canada by
Raincoast Books
8680 Cambie Street
Vancouver, British Columbia V6P 6M9

10 9 8 7 6 5 4 3 2 1

Chronicle Books
85 Second Street
San Francisco, California 94105

www.chroniclebooks.com

ACKNOWLEDGMENTS

I thank all those whose memories revive
these old photographs and give heart to this tale.
I am grateful for the help and encouragement, and for the friendships
I've gained in this rewarding work. Thanks to those both inside and out-
side the community who have guided and aided me. I thank Vanessa
Acosta, Clinton Adams, Felipe and Delia Aguilar, Eulalio and Socorro
Alvarado, Sally Anchondo, Delfina Arechiga, Alicia Arevalo Baca, Aurora
Pacheco Arias, Alicia Brown, Monica Campbell-Hoppe, Eleanor Cervantes,
Fernando Chavira, Zeke Contreras, Henry Cruz, Vince Delgado, Mike de
Santis, Francisco De Leon, Albert Elias, Kitty Felde, Lola Fernandez,
Suzy Fitzhugh, Rudy Flores, Phil Gillette, Tony Gleaton, Julio, Julia and
Steven Gonzales, Reyes Guerra, Therese Hernandez, Gilbert and Esther
Hernandez, Marciano Hernandez, Trini and Nina Hernandez, Thomas
Hines, Carol Jacquez and Bill Rumble, Mary Madrid Kelly, Connie Ortiz
Lopez, Rose Marie Lopez, Constance Madrid, Sarah Malarkey, Della
Martinez, Rose Martinez, Tony C. Martinez, Sherilyn Mentes especially,
Tony Montez, Sylvia Moyer, Sally Muñoz, Catalina Ortiz Provencio,
Virginia Pinedo-Bye, Natalie Ramirez, John Rivera, Carmen Torres
Roldan, Rosie Rosales, Congressman Edward R. Roybal, Frank Sanchez,
Father John Santillan, Lou Santillan, Ruth Silverman, Mary Lou Rosales,
Evelyn Rosales, Pete Urrutia, Mike Vasquez, Raul Villa, Ann Walnum,
Elton Welke, and Geneva Williams.

DON NORMARK
Los Angeles, December 1998

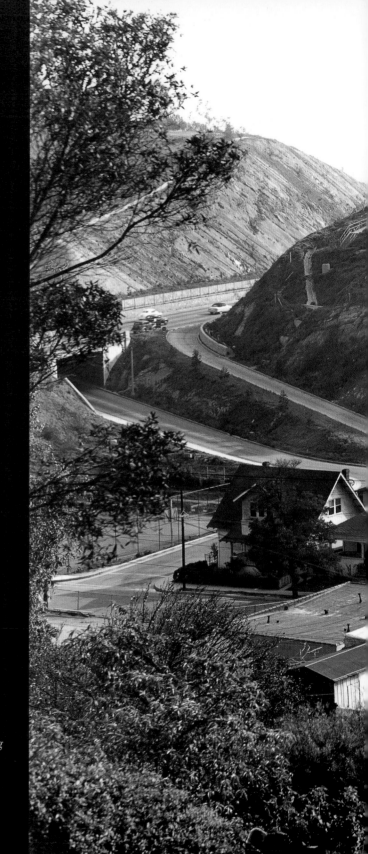

*View over Solano Avenue looking
at the north slope of La Loma.*

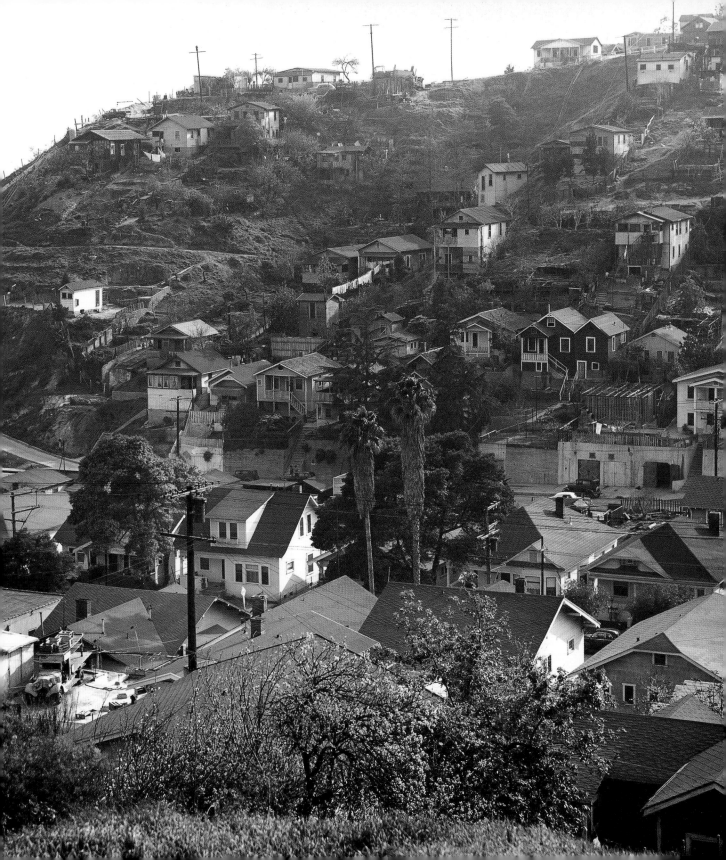

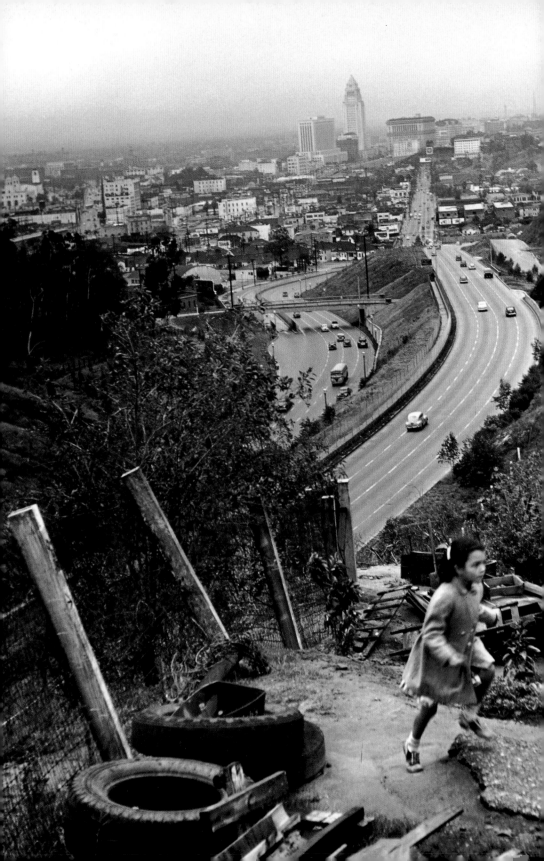

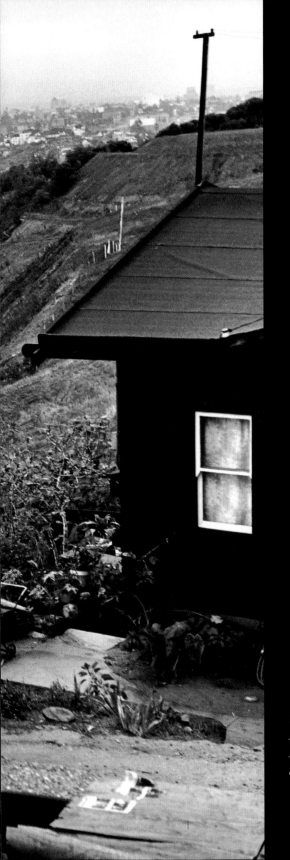

The Pasadena freeway and Los Angeles city hall, seen from La Loma, one of the three neighbor hoods in Chávez Ravine.

One rare clear day in November 1948

I was looking for a high point to get a postcard view of Los Angeles. I didn't find that view, but when I looked over the other side of the hill I was standing on, I saw a village I never knew was there. Hiking down into it, I began to think I had found a poor man's Shangri-la. It was mostly Mexican and certainly poor, but I sensed a unity to the place, and it was peacefully remote. The people seemed like refugees—people superior to the circumstances they were living in. I liked them, and stayed to photograph. I didn't know it at the time, but I was in Chávez Ravine.

I returned more than a dozen times in the next few months to spend long days wandering the dusty roads, searching for scenes that would tell a story. I became a familiar. I would step down from the number 10 streetcar, walk Bishop Road under the Pasadena freeway, and climb a dirt path to the houses of La Loma, the nearest neighborhood in the ravine. The camera hanging from my shoulder was a Ciroflex, a cheap copy of the Rolleiflex. With my picture-taking machine and a pocketful of film I would approach the hill, probably whistling. Whistling was an unconscious habit for which my subconscious supplied the tunes, usually something desperately inappropriate to whatever situation I was in. I loved obscure folksongs then and might easily have been piping the sea chanty *Santianna,* whose mournful refrain celebrates that enormous land-grab known as the Mexican-American war:

> *O then we beat them up and down,*
> *Heave away Santianna,*
> *We conquered all of that Mexican ground,*
> *All on the fields of Mexico.*

The trees and hills of Elysian Park formed the background, the northeast horizon, for La Loma, Bishop, and Palo Verde, the three neighborhoods of Chávez Ravine. In clear weather the San Gabriel mountains fill the sky above the park. That parkland was part of a 1781 land grant from King Carlos III of Spain to the pueblo of Los Angeles. By means of the Mexican-American war, Los Angeles was taken from Mexico, as well as its park, the distant mountains, the rest of California, Texas, and everything in between. I didn't learn until years later that even then, by 1949, plans were under way to take Chávez Ravine from the American Mexicans who lived there, and that the neighborhoods I was setting out to photograph were scheduled for demolition.

I had to work up my courage for these visits, not because I felt I was facing any danger, but simply to overcome my shyness at approaching strangers with a camera. What was I really after? I was really after photographing *life,* and the people of Chávez Ravine lived lives that were a bit more open than those in more conventional American neighborhoods. More of life happened outside their homes, in public, where the stranger's camera could see. Scenes as plain as a kettle filled from an outside tap, or as lovely as an altar to the Virgin being decorated. And the ravine was a finite place, small enough that I felt I might make a set of photographs that could encompass a portion of the life there, that could represent the place. Beyond that, the people allowed me and my camera among them. Some elders treated me with courteous interest, some children greeted the camera with glee, but for the most part my presence was simply accepted. An acceptance that was like a gift to me.

Alicia Arevalo Baca remembers her eight-year-old self seeing a skinny guy wandering around with a camera. "We'll never see *those* pictures," she assured her eight-year-old friends. Recently I heard her say, "But he was just a kid. I don't know how Don did it, how he came and went so easily making pictures." About her old neighborhood she says, "It was *Sal si puedes,* 'get out if you can.' I guess we weren't as bad as I thought."

I had heard of *pachucos* and of gangs, but I was never threatened in any way or even made to feel uneasy. Sometimes a young man would give me a hard look, but that's as bad as it got. I learned later that there were fights and beatings, but I never saw any of it. Walking the streets of La Loma or Bishop or Palo Verde, I always knew I was on someone else's turf. These neighborhoods were as remote and as cohesive as villages. Strangers were few and did not go unnoticed. My most helpful attribute may have been that I looked pretty harmless: tall and skinny, pale and shy. I was clearly no threat to anyone. Even my camera forced a passive stance. Holding it at stomach level, I stood bowed before my subject, my eye looking into the top of the camera. In this posture the photographer seems more vulnerable than his subject, a body language quite different than that of the eye-level, in-your-face 35mm camera I more often use today.

I had heard enough slurs and jokes and casually expressed attitudes to know that Mexicans, whether American or not, did not get the respect from the world at large that I thought was everyone's due. I had some notion that a close look at this

Joe Ceballos, Bishop neighborhood.

community by means of my newfound medium, photography, could help close this breach in understanding. After my last visit in May 1949, I edited a selection of the photographs into a handmade book for which I wrote a brief text. I showed my book around to a few people who seemed favorably impressed. Will Connell, remembered now for his photographs of movie stars, said, "Kid, this is worth fifteen minutes of anyone's time." I thought it high praise. The local editor of *Life* magazine sent my book to the New York office, giving me a few days of hope and fear before it was returned without comment.

I showed a portfolio of prints to Ebria Feinblatt, print curator at the Los Angeles County Museum. She asked for five prints to include in a national invitational show she was preparing called *Photography Mid-Century*. The twenty-seven photographers whose work was shown included most of the current and still remembered stars (Cartier-Bresson, Robert Capa, Dorothea Lange, Arnold Newman, and others) and only a couple of unknowns like myself. With the egotism of youth I thought it simply my due. In her preface to the catalogue, writing of the concerns shown by some of the photographers, Ebria Feinblatt wrote, "the faces of the minorities and underprivileged (Lange, Normark) are brought before the eye in all the vividness and variety of mood and plight."

With my one book made and my money gone, that year in Los Angeles was at an end, and I began to hitchhike home to Seattle. On an earlier trip through Northern California I had shown some Chávez Ravine photographs to Dorothea Lange, and I planned to show her my finished handmade book on this visit. I later read that she was ill and not working during these years, but I was not aware of this at the time. She had liked my photographs, been interested in my project, and had given me encouraging words. I wish now that I remembered what those words were. On my return visit, book in hand, she had been all anticipation, like a motherly cohort. But as she turned the pages and read the few words, the light went out of her, and she turned pages more quickly, glancing up at me a couple of times. She closed the back cover into her lap, heaved her shoulders in a sigh, and passed the offending offering straight-armed back to me, saying, "You've ruined them." I didn't ask how or why or what, nor did she offer any path to salvation. I figured she was right and I figured I knew what she meant, but we didn't talk any more about it, so I don't know. I think my offense was that I had tried to turn my innocent photographs into propaganda in the cause of a good people wronged. And in the process I had uttered clichés and sullied the clarity of the pictures. At least that's the way I came to feel about that book, and I just figured she was on to me, and right, and so no explanation was needed nor any solution possible.

I continued on to San Francisco to visit a photographer friend who was studying at the California School of Fine Arts with Minor White. Cameron offered to introduce me to Minor and suggested that I show him my book. It happened that the class was going to Point Lobos the following week, and after he saw the Chávez Ravine photographs, Minor invited me along. The group would be staying at a hotel in Monterey. I had no money for a hotel room and declined the invitation with thanks. At that, Minor said that if I had a sleeping bag I could probably sleep in Edward's garden.

"Edward," I learned, was Edward Weston. A few evenings later I was unrolling my bag on a strip of mowed grass and weeds between curving rosebeds. I remember that I slept on my back so as to savor the experience as much as possible, to best enjoy the

roses mingling with the cool ocean smell in the air that bathed Weston's hill above the Pacific, and to keep an eye on the stars for as long as I could manage. Edward had told me his routine. When I woke in the morning I watched the pointy-capped tin chimney of his kitchen stove. After it had been smoking awhile I'd pull on my clothes to go knock on his door. He would give me coffee, a good doughnut, and sharp-flavored wizened apples that must have come from some wild tree.

A book from the library, *Photographs of Edward Weston,* had been my chief impetus into photography. Sitting with him at his old kitchen table while waiting for Minor's class to arrive each day was a heady experience, but I could rarely think of anything to say to the great man. I may as well have been mute. He didn't seem to mind, and I tried to convince myself that we were on the same wavelength, communing silently. It never occurred to me to tell him he was my hero. I figured he knew that.

Weston had an open house the Sunday that I was there, and several new strangers were wandering through the small place. Two young women were looking at his nautilus shell where it sat on a windowsill. One of them picked it up. As she turned it, the great shell fell from her hands and smashed, fragments skittering across the floor. The woman burst into frantic tears. Edward, frail at that time and quavering with Parkinson's disease, approached. He patted her on the shoulder. "It's alright, my dear, don't cry," he said, "I have a picture of it."

Home in Washington State, I spent a month
photographing the stump-land farms of Hoogdal, a Swedish community my grandfather and three friends had settled north of Seattle. When I had lived there as a child, Hoogdal was a dozen homes scattered along a mile of gravel road. There was no electricity, no running water, no telephone. I knew all the people and was known by everyone. Auntie Chilberg, the midwife who attended my birth, lived across the road from the one-room schoolhouse where I was the only second-grader. Mabel, the eighth-grade girl who taught me, was a cousin. Everyone kept a couple of cows, a few chickens, some fruit trees, a little garden. English was a second language. Down to the weathered wooden outbuildings and the worn clothing of the residents, it could be seen as a Swedish Chávez Ravine. Despite the wholly different culture, it may have been the comfort of the familiar, I began to think, that led me to spend what time I could in that quiet ravine, so removed from gritty Los Angeles.

The next year I was in New York City, studying at The New School for Social Research, where I took a night class from Alexei Brodovitch, art director of *Harper's Bazaar* magazine. By day I labored in a kosher slaughterhouse, but was fired after a few weeks when my boss learned I attended the New School. He thought only Communists went there. (These were the McCarthy years, when people thought about Communism a lot, both fearfully and foolishly.) I returned to the same state employment agency that had sent me to the slaughterhouse, and this time was directed uptown instead of crosstown, and found a job in the darkroom of *Look* magazine. "Maybe this Red Scare isn't so bad," I thought, but I knew that the fearful political atmosphere had chilled any interest in my photographs of the life of Chávez Ravine. Social commentary had become unpopular, unsafe, un-American. At this same time on the other coast, this same uninformed fear was going to alter forever the lives of the people of Chávez Ravine.

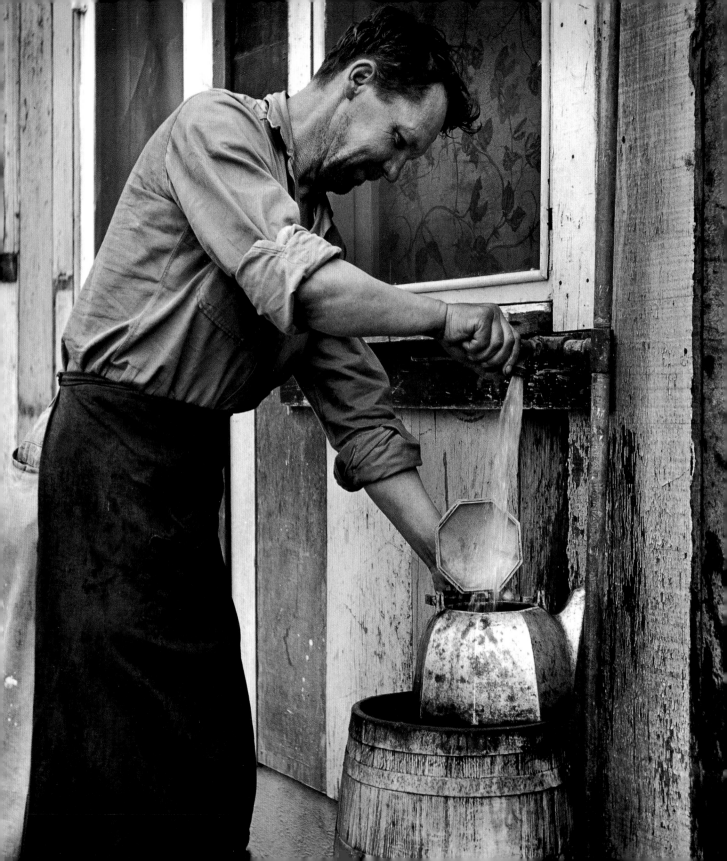

The land of Chávez Ravine had been put to many uses over the centuries. A Tongva Indian place. A cattle ranch, a dairy farm, two brickyards, a Jewish cemetery, a Chinese cemetery. The majority of the people I photographed were born in the ravine. Most of their parents were from Mexico. Some had fled the Mexican Revolution; others were simply looking for a better life.

The four hundred acres of Chávez Ravine form an area of land shaped like a guitar pick in the embrace of Elysian Park, just north of downtown Los Angeles. A struggle for the use of this land began in 1949. A study by the city housing authority had singled out the area as a prime site for a housing project. Money was to come from new federal legislation, the National Housing Act of 1949. The form letter that carried eviction notices to the people who lived there also carried the promise of first choice of the housing to be built. Rents were to be based on income, and a policy of no discrimination was promised. The no-discrimination clause became an issue later because some feared that it meant authorities could not ask a prospective tenant if he was a Communist, a question of urgent import in the fearful early fifties, when Senator McCarthy ruled. The city began buying land and condemning homes. Most people simply sold and left when told to. A few struggled over the price the city offered. Some say they were threatened by the agents; many were afraid to do anything but obey. Where needed, the city took possession by right of eminent domain.

The 1953 mayoral campaign was fought primarily over the issue of Chávez Ravine. The new mayor, Norris Poulson, canceled the housing project when he took office. Chávez Ravine abided. Yet in May

On a north slope, lone Anglo men lived in rental shacks.

1959, with revived interest, the city began forcibly evicting the remaining families.

On May 8, the Arechiga family was the last to go. Television coverage showed deputies kicking in the front door of a home, then carrying struggling women down the exterior stairs. When the house was empty, a ready bulldozer put its blade against the home and shoved it into kindling. The family had lived there for thirty-six years.

Lola Fernandez was one of the young women seen struggling in the grip of four deputies. I showed a video copy of the old film to Lola, her daughter, and her grandchildren. While watching the action on their home television screen, Lola's granddaughter turned to her and asked, "Grandma, is this a true story?"

At the time of the eviction, but off-camera, Lola had been arrested for "assaulting an officer." She spent a month in solitary confinement in the Los Angeles city jail. Her story is perhaps the worst, and she has become a symbol of the brutality that underlies the destruction of a community. A worn sign on the kitchen wall of this still radiant grandmother reads, "When I die, bury me face down so the world can kiss my ass."

When I made these photographs I knew nothing of the political drama ahead or of the upheaval to come in the lives of the people I was photographing. When I returned in the mid seventies I found Dodger Stadium where the people should have been, in a landscape altered beyond recognition. The old residents are steadfast people, and many still live in the surrounding area where their parents and they landed fifty years ago. In their minds, they are still a community. They have formed a group call Los Desterrados, the Uprooted, that meets each year to picnic at Elysian Park, the playground of their childhoods.

Three Neighborhoods Destroyed:

A Brief History In 1946, the City of Los Angeles Planning Commission began work on a housing plan for the city's "blighted areas." A house-to-house study was begun in which homes were visited and residents interviewed. Statistics were compiled in a dozen categories from assessed land values to incidences of tuberculosis. Eleven areas, including Chávez Ravine, were designated as blighted. Chávez Ravine was cited for improper use of land, poor street patterns, a high proportion of substandard housing, poor sanitation, juvenile delinquency, and the presence of tuberculosis.

A letter dated July 24, 1950, from the Housing Authority of the City of Los Angeles was addressed "To the families of Chávez Ravine areas." In twenty-six lines it dropped a bomb on the communities. It read in part: "This letter is to inform you that a public housing development will be built on this location for families of low income. The attached map shows the property that is going to be used. The house you are living in is included. . . . You will be visited by representatives of the Housing Authority who will . . . inspect your house in order to estimate its value. It will be several months. . . before your property is purchased. *Later you will have the first chance to move back into the new Elysian Park Heights development.*"

In October 1950 the city council approved $110 million for ten thousand housing units to be constructed at the eleven selected sites.

Elysian Park Heights was considered a special plum for architects Robert Alexander and internationally famous Richard Neutra. Near the city center, with only 40 percent of its land occupied, Chávez Ravine seemed to offer planners and designers an ideal opportunity to improve the lives of low-income residents. The site was three-quarters of a mile square. The number of housing units was to be tripled. Neutra designed twenty-four thirteen-story towers and 163 two-story buildings. Historian Thomas Hines noted that the redevelopers, including Neutra and Alexander, admitted that the area was "charming," and that the residents seemed happy and well adjusted, with an intense feeling of pride in and identity with their communities.

In 1951, foes of public housing began to attack this "creeping Socialism." On December 26, 1951, the city council canceled the city's contract for redevelopment by an eight to seven vote. The housing authority then asked the court for a ruling on the legality of the contract cancellation.

In response, the city council ordered a referendum election for June 3, 1952, to ask the public whether to continue with or abandon the public housing projects.

In April 1952 the California Supreme Court ruled that the city council could not cancel its contract with the housing authority, and that the referendum would have no legal effect on the contract. Despite this ruling the city held the referendum election. Six hundred thousand people voted three to two against public housing. California senators Richard M. Nixon and William F. Knowland then pushed for federal legislation that would make the contract cancellation legal.

By this time most of the people living in the ravine had simply done as they were told they must, and had sold their homes to the city and moved out. Some of the empty dwellings were set ablaze by the fire department, training recruits in fire-fighting

Sarita Muñoz and her wary doll, La Loma.

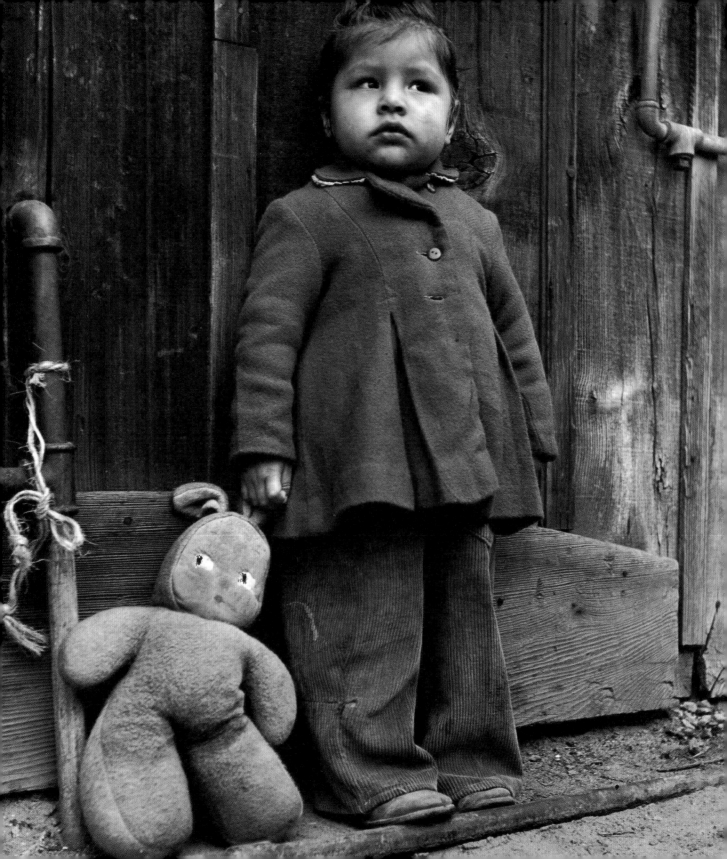

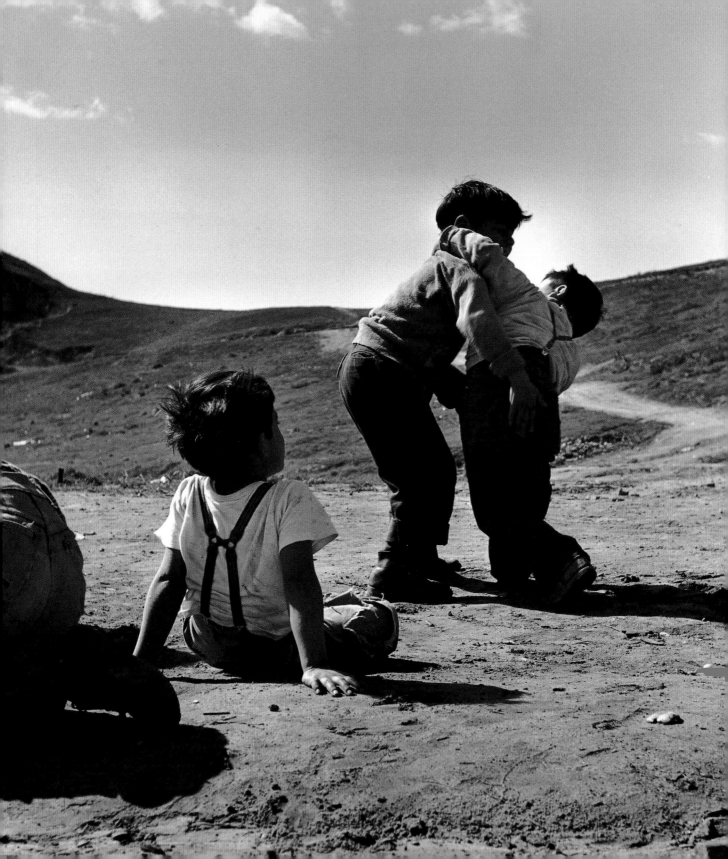

techniques. Others were auctioned off to be stripped of their valuable components: doors, windows, hardware, bricks. The few individuals who defied the eviction notices were impelled in part by a determination to get what they considered a fair price for their property, and in part by a deep reluctance to abandon the neighborhoods that had so long been theirs.

In the autumn of 1952, during a period of hyperventilating anticommunism, three top administrators of the housing authority were called before the California Senate Un-American Activities Committee. They all took the Fifth Amendment. They were all fired.

The U.S. Supreme Court affirmed the California court's ruling that cancellation of the housing contract was illegal.

In June 1953, Norris Poulson became mayor of Los Angeles. In his antihousing election campaign he promised to end "federal domination of the city." Once in office he renegotiated the contract with the weakened housing authority so that the two largest projects, including Chávez Ravine, were abandoned.

In July 1953, the U.S. Congress passed legislation under which the federal government would absorb the difference (loss) between monies already spent and the future sale price of Chávez Ravine for other purposes. In August 1953, the housing authority sold 170 acres of Chávez Ravine to the City of Los Angeles for $1.25 million, a loss to the federal government of more than $4 million. Congress authorized this sale on the condition that the city use this land "for public purposes only."

At this same time Walter O'Malley was failing in his attempt to negotiate a new stadium site for his Brooklyn Dodgers with the city of New York. In early 1957, Los Angeles mayor Poulson and other city and county officials met with O'Malley to offer him a stadium site. On October 7, 1957, the city council approved a resolution to transfer Chávez Ravine to the

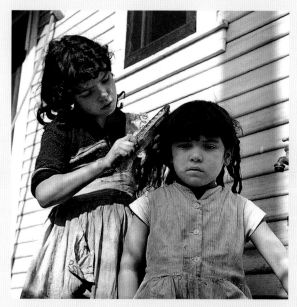

{Above} *Patricia Barreras (Punky) combs the tangles from the hair of her sister Lillian (Chema).*

{Left} *Boys fighting for fun in the open hills.*

Dodgers. On December 1, 1958, a referendum to block this private takeover of public land was put to the vote. The Dodgers won by a margin of less than 2 percent.

Ruling on the several lawsuits to nullify the city's contract with the Dodgers, superior court judge Arnold Praeger found the contract invalid because it was "an illegal delegation of the duty of the City Council, an abdication of its public trust, and a manifest gross abuse of discretion."

On January 13, 1959, the California Supreme Court ruled in favor of the Dodgers. In May of 1959, using the power of eminent domain, the police force, and, finally, bulldozers, the city evicted those few families that had still refused to leave their homes.

On September 11, 1961, construction began on Dodger Stadium.

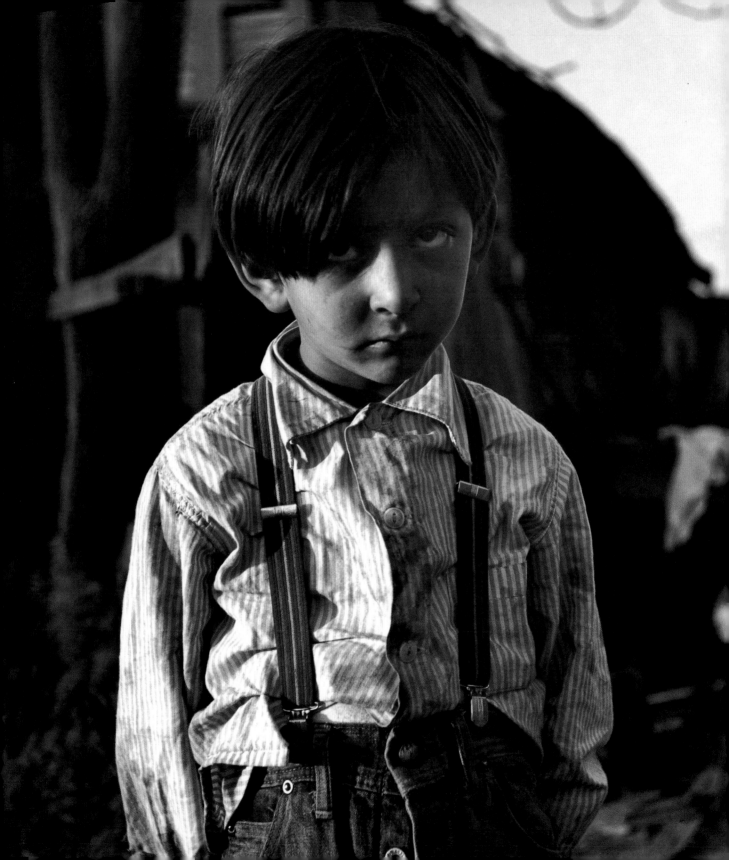

This is the photograph Frank was holding. Everyone liked this boy, but no one knew his name.

In 1997, a story in the *Los Angeles Times* about a priest remembering his lost home in Chávez Ravine provided the thread that led me to the whole scattered community. On Palm Sunday I met a few people in the church of Father John Santillan, a couple of miles from Dodger Stadium. I placed a little stack of about a hundred small photographs on the table and began to pass them around, watching faces for response. Alicia Arevalo Baca was the most outwardly expressive. She sighed, she dabbed at her eyes with a handkerchief, she laughed and spoke out the memories evoked by the prints. The men were more stoic, especially Frank Sanchez, a silent man with a stern Indian profile. As the prints went around, one seemed to stop him. He held it for a long time in his two tough hands. His expression softened as I watched. Then he nudged his neighbor and held the little print for him to see. I leaned in to hear what he might say. "Isn't that cute," he said.

I spent months spreading these photographs on tables in homes throughout Los Angeles to hear old stories about this place that once was and is no more. It has been a continuing joy for me to find again these people whom I knew such a long time ago, and to hear their memories and stories give voice to and amplify my silent old images.

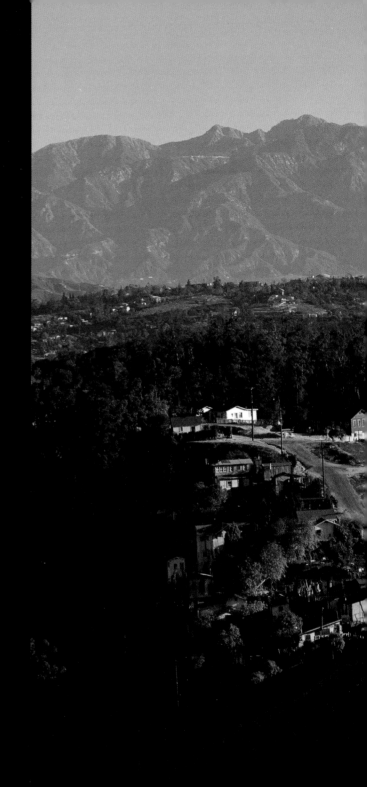

Murphy Hernandez: "I knew those hills like a bird."

Sally Anchondo: "In all my life I never thought
I'd ever see all this again."

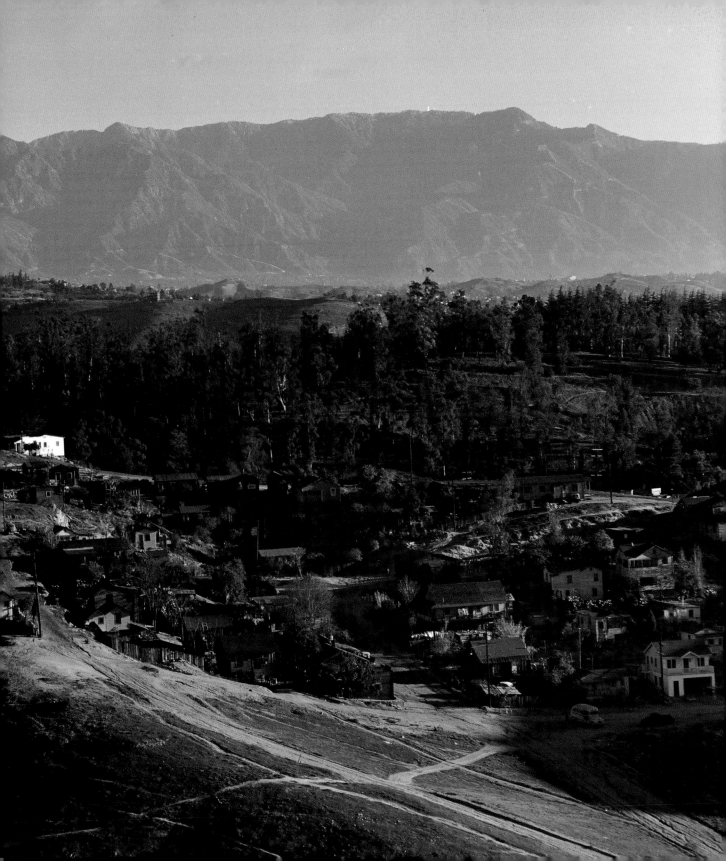

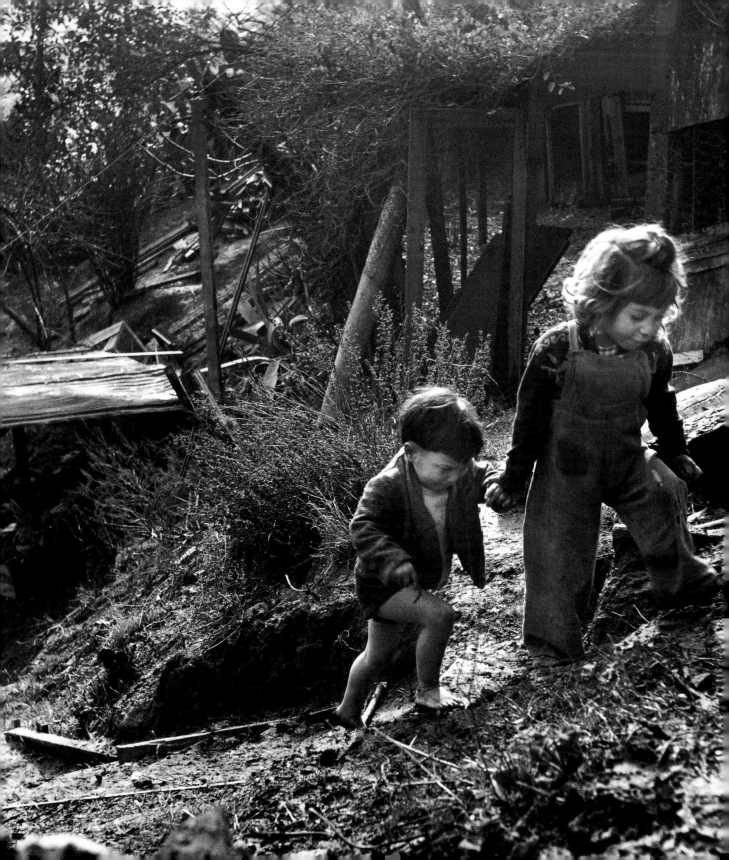

Henry Cruz: You know, a picture like this might look a little depressing to other people, but not to us. That's us right there. The reality. Look at the expression on those kids. That's the way this neighborhood was.

Reyes Guerra: It's a beautiful picture. It shows the way we used to live. Kids nowadays, they wouldn't let them play like that. People were rougher then, even the kids.

Carmen Torres Roldan: We were going down from La Loma, down into Solano, going to General Hospital, and it happened that my mother had twins. I was born in the door of Elysian Park, and then my twin was born in front of Solano School.

As we grew up it was really a nice feeling because everybody was like a community. We were all like brothers and sisters, and the mothers were all *comadres* you know, they baptized each other's children. And what was really, really special was that on Saturday, five o'clock in the morning when the sun was just coming out, the boys used to play the guitar and serenade everybody, and it was so beautiful to hear the music in Spanish.

Our parents spoke Spanish, and when we went to school, we had to learn English. We weren't rich, but we had all that we needed. Everybody got married with each other up there because everybody had their boyfriend next door or down the street. Nobody went out of the neighborhood. Then everybody was invited to the wedding. Saturday was the day everybody took their baths, then on Sunday you had your Sunday dress. That was the only day you wore it. At Santo Niño Church in Palo Verde they gave us little coupons for attending Mass. And once a month rich people would give toys and clothes and things. We used to go spend those little coupons and get dolls and toys because, you know, we could not afford them. Then in La Loma a lady named Calita donated a little house that became our church. We had Mass in the front room. The fireplace was the altar. The bell was made by the men. They dug the form for it in the back yard. Then in August or September we had a big Jamaica, which is Carnival now, but at that time it was called a Jamaica. Everything was donated and we made money. That is when the church began to be built, probably in '48 or '49.

In about 1951 we left La Loma because everybody was moving. They were giving very little bit money. People that got state aid, they would reduce that from the money when you sold the house to them. They gave my uncle about $6,000 for the house, and that is when we started looking around, seeing what we can buy. But anyway, other than that, it was a very nice—and very, very, very good memory, very sentimental memories, because we had a beautiful view. You could be on top of the hill of La Loma, right there, and you can see everything, and it was like—a breeze. A real, real . . . clean breeze. Not like today that there is so much people.

The book that lies open on her lap is titled Enchanting Stories.

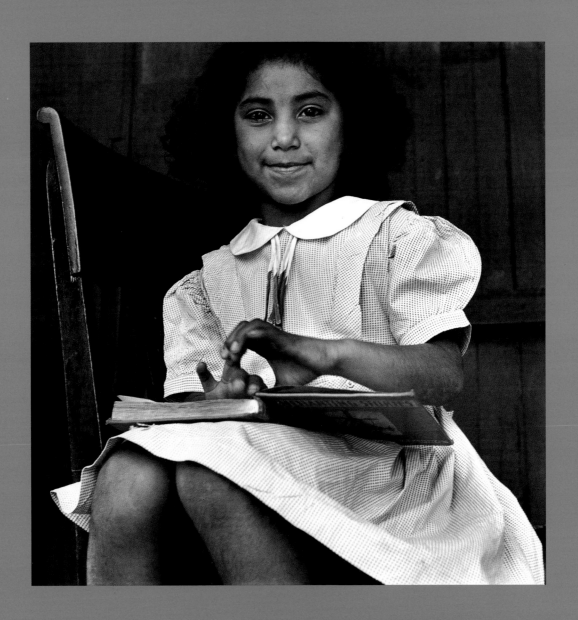

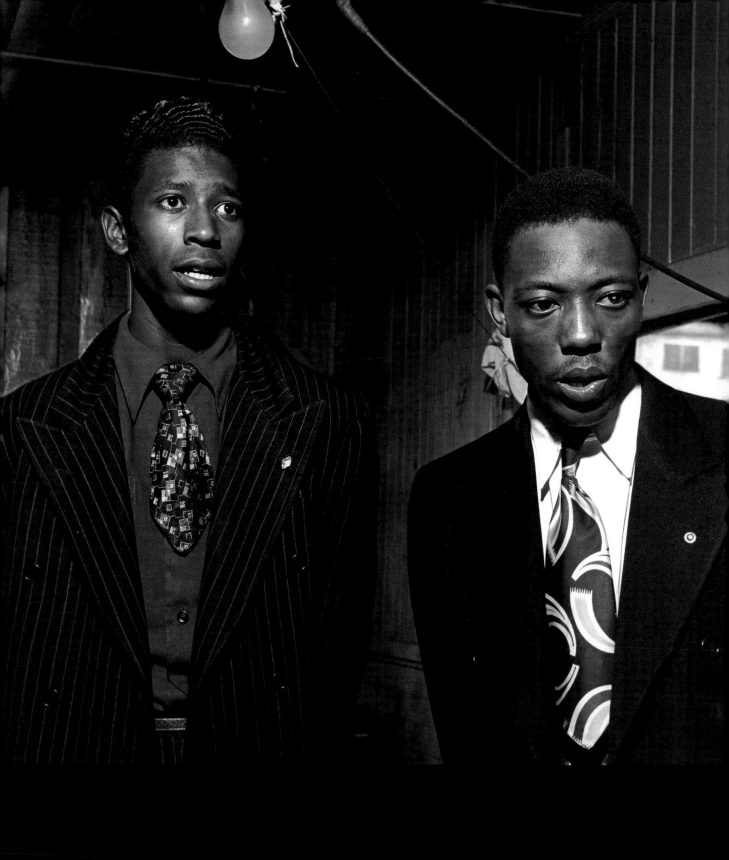

Felipe and Delia Aguilar:

FELIPE: I had cousins in La Loma and I had a whole mess of cousins in Bishop. Around the corner was a store with an apartment upstairs. The store belonged to an African American. It was a malt shop. After school the bus dropped us off there, and they would teach us how to dance. They would put the music on for us. We didn't have no money. When we did have money, we bought ice cream there. Jitterbug to them was a great thing. We went there to listen to the music, and the husband would tell us, "Why don't you kids learn to dance?" We knew how to dance in our way, but this was jitterbug. Him and his wife used to get up and we watched them, but it was too hard. Too much movement under your feet. But they taught us, whoever wanted to learn. Our parents liked for us to be there. They knew where we were. They always put the music on for us. They lived there about two years before they moved. I think they had a son who wanted the rough life, and they moved out.

My father got paid by a shopping bag of groceries and a little bit of money. My mother said, "That is one thing for sure, your father always had milk in the house." And there was always rice, beans, potatoes, and a little bit of meat. My grandma said too much meat is no good.

DELIA: My mom didn't want me to date Felipe, but my cousin would go with me on the trolley, and we'd climb this hill where I could see his house. We'd sit there and I watched for him to come in or go out the door. That was a big thrill for me.

When I got married I walked all that street of La Loma in my bridal gown and veil. I was an outsider, but it was like a family. Everybody came to the wedding. Everybody ate. They all knew each other. That night I was so tired I went into the home of one of his aunts. The women helped me with my dress and put me to bed so I could rest for the dance. And when they were looking for me, "Where's the bride?" She was asleep in the house of someone she didn't even know! That's how people were. Everybody was invited. I still visualize myself walking that little street from one end to the other. They were great people. That is why I am sad that they left their homes, because it was a community. That is why my husband goes every year to the gathering. They have not forgotten those memories.

Albert Elias: I was born in Palo Verde in 1931 and lived there until my dad sold in 1951.

When I was a kid there was an abandoned house on the corner. All the windows were broken. Kids used to play in there and mess it up. My dad said, "I want to know who that house belongs to. I want to rent that house." It belonged to Mr. Stimson, he learned, a lawyer in downtown L.A. I remember going with my dad to talk to Mr. Stimson. He said, "Mr. Stimson, you have a house at 1801 Gabriel Avenue. Right now it is empty. It's abandoned, it's beat up. I want to rent it."

Mr. Stimson said, "Okay," and he asks his secretary, "Hey Josephine, what is this house that I have over there?" He owned all kinds of houses over there. She looked it up and told him it's been empty for years. And he said, "Mr. Elias, why don't you fix it up and when it is ready where you think you can move into it, then I'll rent it to you." He was smart. So my dad every weekend and whenever he could would work on it. He got his brothers and his friends to help him. He went to the dump and got some windows and doors. He got it livable.

So he went back to Mr. Stimson. "I got the house ready to move in."

"Okay. You can rent it. Go ahead and move in."

"How much are you going to charge me?"

"Oh, about three dollars a month."

This was in 1936. Nobody had any money. My mom and dad used to pay cash all the time. They never trusted the mail. I remember going with my dad to Mr. Stimson's office upstairs on top of the Million Dollar Theater at Third and Broadway with the rent every month. Sometimes he was short fifty cents, "I am short fifty cents, but I will make it up next month."

"Fine, Mr. Elias, fine." He was a good lawyer, a good guy, Mr. Stimson. But I think he got tired of seeing my dad come in. One month he said, "Hi Mr. Elias, come here, I want to talk to you. Why don't you buy that house from me?"

Dad was surprised. "Sometimes I don't even have the rent, and you want me to buy it?"

"Yes, I want you to have that house, I want you to buy it. Tell you what, I am going to let you have that house, no money down, and you pay me whatever you can, every month."

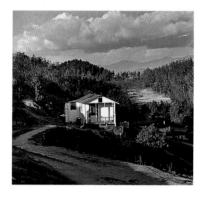

House isolated at one edge of the ravine against Elysian Park. The open field in the distance was a meeting place.

My dad said, "Alright!" and we rushed down to where we'd left my mom in the car and he tells her, *¡Vieja, Vieja, ya compré la casa!* "I just bought the house!"

"What do you mean you bought the house?"

"I bought it. He told me no money down, whatever I want, I can give him the payment."

My mom said, "Okay. How much did you buy it for?"

"*Aiii,* I forgot to ask him." So we ran up the stairs and he rushes into the office and says, "Hey Mr. Stimson, I know I bought the house, but you never told me how much."

So he says, "Hey Josephine, how much did I say I was going to charge Mr. Elias here?"

She says, "You said $475."

"Alright, you got it for $475." The secretary had the paperwork done and my dad signed it and she gave him a copy, and we went home. He was real proud. "I am buying a house." He used to pay four, five, six dollars a month. Sometimes two dollars. He didn't have a steady job. He would have a job for a week or two and then the job ended and he was laid off. Finally, about 1939, he got a job at the Southern Pacific. When the war started in Europe they started to hire a lot of people. So he went to work with Southern Pacific. With a steady job he paid off the house right away and he had money to fix it up. He roofed it, brought water inside, put in a water heater. That is how he bought the house. He was one of the first to sell. They went to everybody one by one. Some of them sold right away. It started in 1948 or 1949, rumors that they were gonna come in and take over the whole neighborhood. They were going to build a hospital, a youth center, low-rent housing, something. We were having dinner one night, and my father said, "I sold the house."

I said, "Whhaat!" He sold the house. "Why?"

"They offered $9,600. I thought that was pretty good." I didn't get mad at him but I told him that he should've talked about it, see what everyone was going to do. But he signed the papers right away. He bought a house in Lincoln Heights for $15,000. That put him in a hole and he was already in his sixties. When they offered him that $9,600, he thought, "What a profit." He thought he was making a killing.

I used to go back all the time to see how it was. A lot of the houses were bulldozed down, and they moved those that could be moved. Our house was moved. I looked for it, but I never could find where they put it.

Mary Madrid Kelly: Those rocky little roads. It was a long story getting there.

Gilbert Hernandez: The houses that were empty, they came and knocked them down, then cleared the land, except for the Arechigas and the Davidsons. In 1959 I was working for J. Thompson Construction Company. We had the contract to move the dirt for Dodger Stadium. Nine million yards to be moved in one year. That job was subbed to Vanil Construction Company. Tomay did the fine grade, Southwest Paving did the pavements, and some company from New York built the stadium. Ballan poured all the concrete when they put in Stadium Way from Riverside Drive. The lot where I was born is still there. They didn't mess it. The land of La Loma is still there. The lots are landscaped with ice plants and palm trees now.

Climbing the hill to La Loma with an armload of groceries.

The reservoir on top is still there. With that as reference, I can tell where our house was and where Effie was. Paducah, Malvina, Reposa, Davis: I remember the streets of Palo Verde. And in La Loma, Pine Street, Yolo Drive, Spruce Avenue, and Brooks Avenue, where we lived. I can remember all of the streets just like a dream. I can close my eyes and see how it looked. Everybody lived so happy there. Back in the hills where they built Dodger Stadium, we made model airplanes and kites and flew them up on top. From that hill, you could see Santa Monica, Playa del Rey, and all the ocean.

Davidson Brick Company was there many years back. My grandfather and uncle hauled the imperfect bricks to their house to build the driveway. The sidewalks by my grandfather's house in the back and in front were all brick.

I liked to sit and listen to my grandfather. He said we came from Mexico in 1905 when my father was five years old. My grandfather's name was Bruno Hernandez. He tried three times to come into California. He came to El Paso, Juárez, and crossed Arizona, but he couldn't make it; too far and bad desert. Then Nogales; desert again. Finally, he came through Mexicali, the Salton Sea, Calexico, through there. Palm Springs. Mexicali was just a dinky border town, and Palm Springs was nothing. There was a wagon trail which they traveled on through San Bernardino to Colton. They stopped in Colton, where the railroad was being built, and again in Culver City, which was all ranches and swamps. They came on horseback with a wagon.

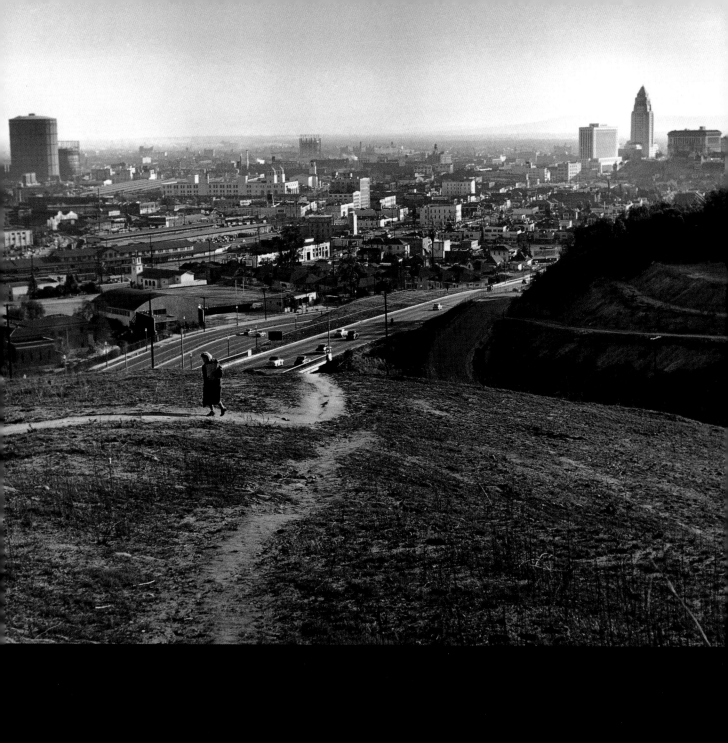

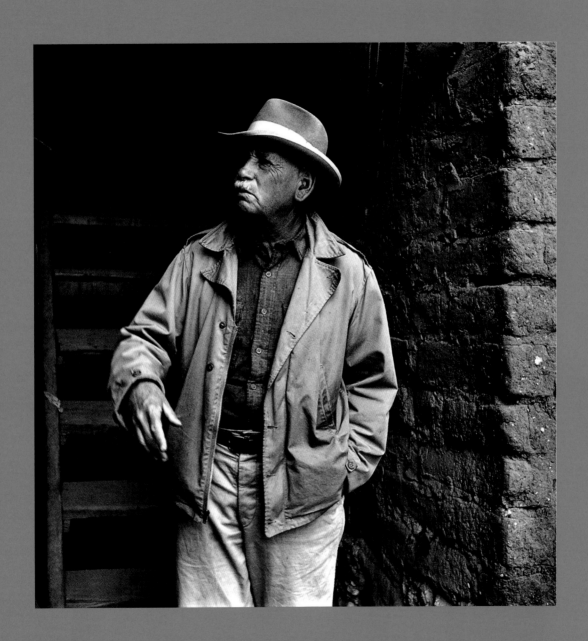

In 1911 they got to Los Angeles and found some land in the Chávez Ravine. The lots were on Brooks Avenue in La Loma. My uncle Domingo built a house there, my grandfather built a house, and then my Tío Candelario and my Tía Natalia came. My uncle Domingo's address was 1726. The address where I was born was 1724; my other uncle's house was 1714; and my aunt's was 1716. My oldest daughter was born at 1716 and my other daughters were born right on the corner across the street. My wife, Tepi, was born in the same block. We were married at Santo Niño Church by Father Tomás on August 30, 1945.

When my dad passed away in 1937, he was thirty-seven years old. We were very poor. My mother passed away in 1940. When Roosevelt became president he put in the welfare program. They gave us shirts and shoes and corduroy pants, but everything was a dark green. At school, everyone knew who was on the relief. Kids would say, "He is from the 'gimmie gimmie' look!" I felt embarrassed about it.

We picked apricots in May. In June, tomatoes and cucumbers and all the work on the farms. We would pick the grapes in August. Walnuts would start in September. To me it was a lot of fun. To my friends it wasn't. From Burbank all the way to Chatsworth was nothing but farm-land, walnuts. Now there is only a lot of houses.

The streetcars were good. One red car went to Canoga Park. Another red car went all the way down to San Dimas, Arcadia, Monrovia, and Azusa and another one to Long Beach and to Santa Monica. The number 5w yel-low cars went to Eagle Rock, Mt. Washington, and Cypress. The main car went to Lincoln Park. The V car went to Spring and Sunset. Fare was seven cents. The red streetcars were a dime. Sometimes we'd ride to the end of the line and stay in our seats and ride back. They wouldn't charge you if you didn't get off the car. They went down the aisle, bang, bang, bang, flipping the seats so they faced the other end. The conductor would get off and pull the cable down and wrap it up and then transfer his coin box to the front end. It was a lot of fun. I went on the streetcars to school.

My dad worked in a laundry for many years and so did my uncle Domingo. My uncle Candelario worked for the Yellow Transit streetcar company. My grandfather was old then, and didn't work. He would pick up pieces of metal or rags, anything he could sell. When we'd leave to pick grapes, he would come with us. When I started getting paid by the hour in 1944 they gave me thirty-five cents an hour. When I retired in 1990 I was making thirty-five dollars an hour.

Zeke Contreras: There was only one road coming in from Broadway, Bishop Road, that went into Elysian Park. My grandfather and some of the early immigrants cut into the hill to make Effie Street, so they could go down into our valley. "The Lost Colonies," newspapers called it, because nobody knew a valley was there. We had to walk all the way to Broadway to shop. I'd go with my dad to the Third Street Market to buy groceries. We would catch the streetcar on Broadway and carry the food way up the hill to where we lived. We did not have paved streets, just dirt roads. They had sidewalks made out of wood. The Westlake family owned a brickyard. A lot of the local people worked for them. Where Dodger Stadium is situated now, part of that hill where they built the bleachers was already excavated. That's where for many years they had dug out the adobe to make the brick. Los Angeles was paved with brick, a lot of it from Chávez Ravine.

People coming into Chávez Ravine looking for our settlement were told to go up Bishop Road until they came to a green tree. That was the *palo verde,* that green tree. I believe it was a pepper tree. "Just go beyond the *palo verde,* and you are on the right road." That is how it came to be called Palo Verde. Later on, when they put the school, they named that Palo Verde School, and it was official. We knew everyone in the Chávez Ravine.

During the depression of '37, '38, and '39, my dad wasn't working. So in the summer, when I was out of school, we had a chance to pick walnuts, apricots, grapes, and cotton. We would tell the neighbors that we'd be gone for two or three months and take off. We didn't even lock the doors. Leave everything open, toys outside, no one would bother. Everybody had fruit trees. Fence made out of nopales. There was mustard plants growing wild, parsley. I would go up to the hill to pick stuff and dad would cook them. Most everybody had chickens and rabbits and a few people had pigs and cows. There were horses roaming the hills, and goats. Like being out on the open range.

Palo Verde neighborhood
with Elysian Park beyond.

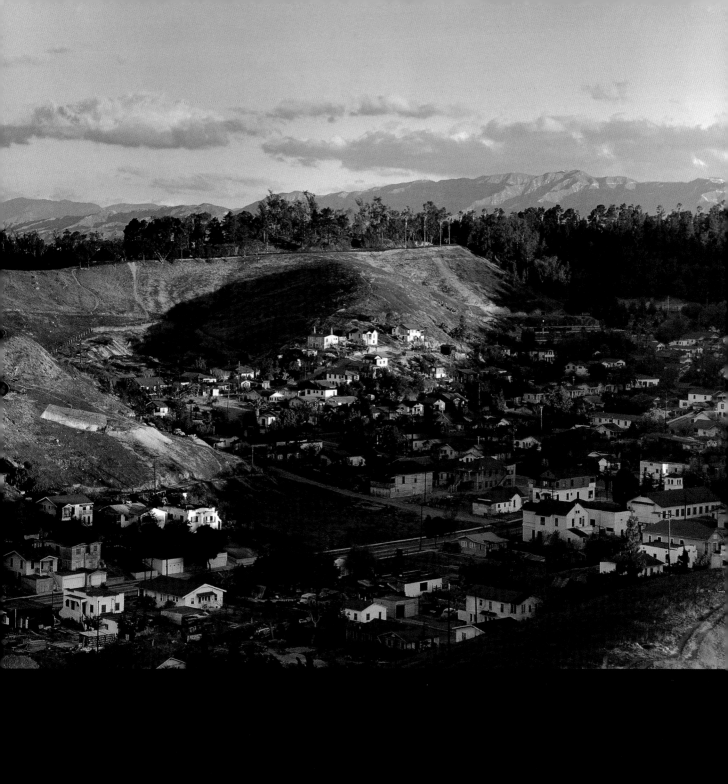

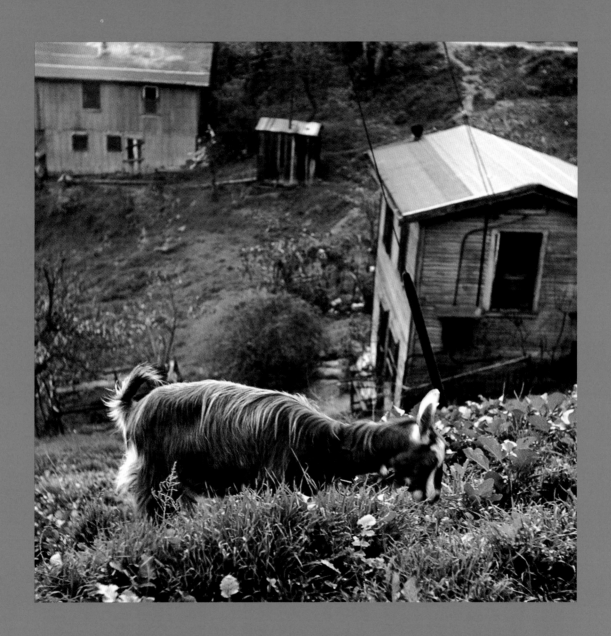

Sally Anchondo: We raised chickens, rabbits, goats. We used to
take the goats up the hill when the mama goat had little babies, so they
could run around. We'd take formula in a bottle with a nipple and we
fed them in the hills. We had a lot of good times.

Lou Santillan: After leaving, it was sad going back to visit. There
were fewer and fewer places. Bulldozers working and trucks hauling
stuff away. Weeds growing, streets going to hell. Abrana Arechiga, still
holding out, would yell at us out her window, "What are you doing here?
You abandoned us." I remember watching old Arechiga stake out his
goats over on the next hill. You'd see him hit the stake, and raise the
sledge again and *then* you'd hear the sound. Like none of it was real.

*From a Kitty Felde radio series on the history of the Dodgers, circa 1986.
The voice is that of Bob Hunter,* Daily News *sportswriter who drove into
Chávez Ravine with Walter O'Malley.* "We didn't know where it was . . .
had to ask instructions at a little gas station on Sunset Boulevard. We
drove down in there and there were three or four or five little shacks,
squatters' shacks, which of course the Dodgers had to deal with in tak-
ing over the territory . . . and some goats out there on chains. Truthfully,
there were *goats,* three or four or maybe five, six *goats* and junk and
debris and old tires and stuff."

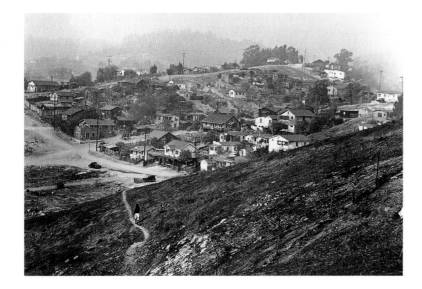

Woman approaching neighborhood of La Loma from city-owned reservoir property.

Sally Anchondo: The bottom street is Effie Street. The one on top of the hill they called *el trenicito,* the little train. When we were small, my grandfather, Luis Muñoz, used to send us to sell fruit. That was embarrassing. We knew the kids and we didn't want to knock on the door. But my grandfather would say, "If you don't go, you are not going to have food in your mouth, you better go." So we'd go sell bananas and the people would look at them and feel them. By the time we found a customer, the bananas were too soft to buy them. So my sister and I would sit up in the hills and eat them ourselves. I would love for my grandkids to grow up someplace like that. Everybody knew everybody and it was beautiful. We used to do everything here in the hills.

Tony Montez: Those houses were *small.* When they had parties they'd put the furniture out in the backyard. There were parties every Saturday night almost. My dad taught me to play the bass when I was about nine. When I played at parties with him, he paid me my share. We had the bass, two guitars, a fiddle, and a sax. We played boleros, cumbias, sometimes waltzes, border music, popular stuff. We played all the time, and they paid us. Not much, but there was always stuff to eat; the women would be making tamales, menudo, pozole, everything. They'd put powder on the floor so you could dance. Floors were rough, wide boards. Nobody could afford linoleum. People that weren't invited would stay out on the porch to talk and hear the music.

Gilbert Hernandez: You'd see artists painting in the neighborhoods on weekends. My father-in-law was a gardener and I worked with him in the forties. He worked for some movie stars. We did Alan Ladd's garden, William Bendix's, and J. Carroll Nash's. At one of the houses we took care of, the lady invited us in to have some coffee. She had a painting of my aunt's house on her wall! They added landscape, but it was my aunt's house. She said she bought it at an art gallery.

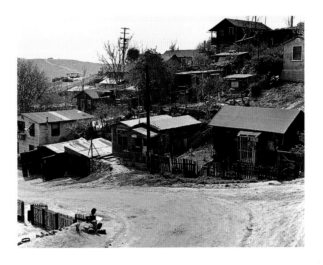

Art student with drawing board in his lap sketching houses in La Loma.

In a letter dated July 1997, artist Clinton Adams said, "It pleased me to know that I wasn't the only one interested in Chávez Ravine, back in Los Angeles's more innocent days of the late 1940's. I was teaching a course in landscape painting at UCLA. A search for interesting subject matter first took me into Chávez Ravine. I returned a number of times, either by myself or with a class, and compiled a series of watercolors, principally in 1950–51. Most were sold a long time ago, and I have no record as to their present whereabouts. One of the Chávez Ravine watercolors is in a private collection here in Albuquerque, and an oil painting developed from the watercolors is in the Albuquerque Museum.

Of course Chávez Ravine was displaced by the powers that be in L.A., who were willing to do whatever it took to bring the Dodgers to town. In Los Angeles, history tends to be erased by what is thought of as progress. I prefer to remember the city I knew as a child and teenager (I am seventy-nine now); I liked it better back then."

Lupe Loya's grandson thought this looked like The Wizard of Oz, *"with all those crooked fences and things." Sylvia Moyer, an elegant woman, talked about the place looking sort of sad and grim in the photographs, "because they are black and white," she said. She remembered La Loma as green and bright with the flowers of her childhood.*

Of this scene Sylvia said, "Look at this tin roof. On a rainy day you'd hear the rain pounding, while all around it were beautiful flowers and things growing wild. It was just there and suddenly you would notice how beautiful it was."

Sally Anchondo: I will never forget one little old man. They called him Valentine. He used to dance for us and we'd throw him pennies. We did not have dimes or nickels then, we threw him pennies. He lived there by the first pole. The song that he sang was Los Animalitos. He used to dance and sing,

Los Animalitos,
se mueren de hambre,
se mueren de hambre.
Porque son huerfanitos
de padre y madre,
de padre y madre.
Arrímense todos aquí.
Les voy a cantar algo muy bonito,
O les voy a cantar una canción muy bonito.
Los animalitos, los animalitos
se mueren de hambre, se mueren de hambre . . .

We liked to hear him sing, you know. He used to drink a lot. But he was also a very good man.

Eulalio (Lalo) and Socorro (Cora) Alvarado:

Lalo: This is Brooks Avenue.

Cora: No, it's not.

Lalo: Yes. This is Brooks Avenue leading down here.

Cora: We disagree on that.

Lalo: It's Brooks Avenue with the tortilla factory at the end.

Cora: Yes, and also the woman who sold *nopalitos,* but it wasn't Brooks Avenue.

Lalo: She sold a lot of *nopalitos* at Lent. She had a son named Heraldo. We had a Mexican newspaper called *Il Heraldo,* and Heraldo used to deliver *Il Heraldo* on horseback. From Brooks Avenue.

Sally Anchondo remembered who lived in every house in view, as well as in those houses out of camera range across the street.

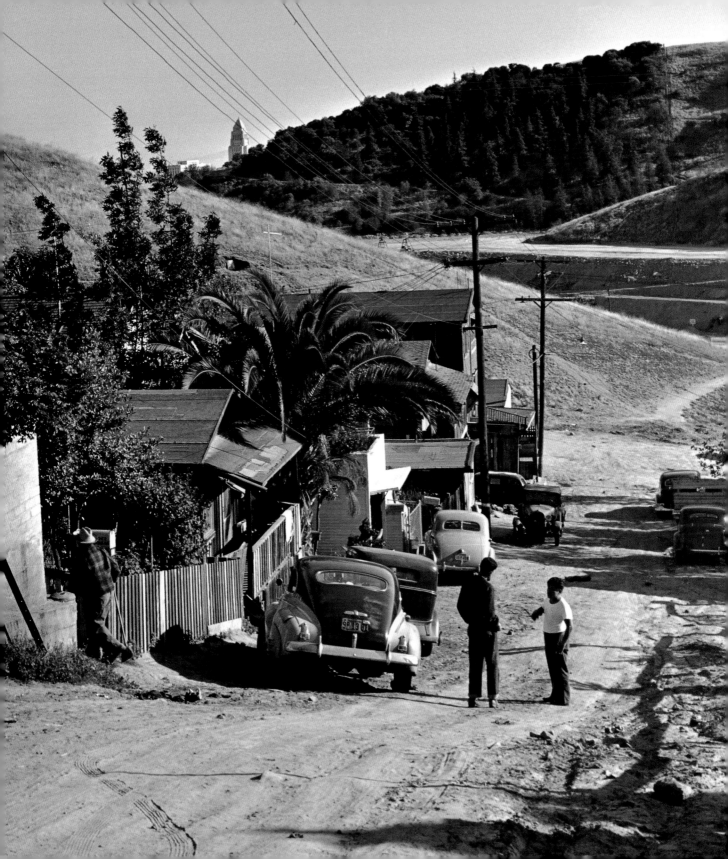

He had beckoned me in from the glaring road to the shade of his porch. He spoke no English, and I spoke no Spanish, but we conversed. He compared me to his favorite grandson. He with his big hands and lean working frame felt at times like my grandfather again. We got on well.

Murphy Hernandez: There's Don Bernardo. Boy, that man used to dance. He was king of the hill, that old man. He had a lot of kids. Mean. They were all mean. I think one still lives in Tijuana.

Rudy Flores: Bernardo Ramirez had a lot of property. He'd rent for ten dollars a month to guys who didn't have no wives or nothing. Rented them a little room. If they couldn't pay, they worked for him building terraces. He bought an empty lot and would dig steps and plant cactus. On the bottom he made it so you could park cars. He would rent the parking space.

Frank Sanchez: Everybody liked Don Bernardo. You could get credit at his store. He let you have it, if you were short on money. He was well liked around the neighborhood.

John Rivera: Our neighbor had about twenty-five yucca plants there. Don Bernardo Ramirez used to come and drain them. He would ferment the juice. Make tequila, I guess.

Carol Jacquez: In the church processions, I was one of the little girls in white carrying a basket of rose petals. I'd throw rose petals in front of the altar boy who carried the cross and the men carrying the Virgin. I have pictures of me as a little angel. They made me wings, and I learned to fold my hands and to sit quietly. Around Easter the priest used to wash the feet of the young boys. He would wash their feet and pass out loaves. The women from the altar society decorated the church. Those statues, the colors, they were really art pieces.

Madre Carmen was the Superior; then there was Sister Catalina, and Sister Clarita. I remember one of them saying, "Little girls do not wear pants. Little girls are supposed to wear dresses. Think what a boy would look like with a dress on! Then why ever would you want to wear pants." The way I was raised, it is a wonder I made it to being a free thinker.

There was a lot of, you know, *pachucos.* My dad said that he could not date my mother without having to fight with two or three guys before they allowed him into the neighborhood. It was so parochial, that feeling that the girls in the neighborhood belonged to the boys in the neighborhood. My father was raised on a farm in Santa Fe Springs. His father died working on that farm, and his mother and brothers and sisters stayed on. He remembered when the *patrón* came and picked the young woman he wanted to be with in an evening. He remembered going to the movies when Thursday night was Mexican night and that was the only time they could go. This was in the 1930s near Downey, here in California.

But then he got a job working in a foundry, and my mother worked there. My *tía* says that my mother came home one evening and said, "You should see this guy. He is so strong. He is shoveling coal, and the sparks come up and hit him and illuminate him and bounce off him. He looks almost like Jesus."

"Gringo" is not a derogatory word, it's just for identification. When we Latinos were categorized as "white" by the federal government, it became a problem. Because that threw us in with the big population that does relatively well. So to differentiate ourselves we became *Chicanos.* Mexicans in Mexico feel that they have the true culture. They call us transplants and *Pochos.* The *gringos* viewed us not really as equals. And we really didn't want to call ourselves "white." To call ourselves Mexicans wasn't right either. So we became Chicanos, and created this mythical land of Aztlán.

Esther De Leon preparing an altar for Corpus Cristi near the family store, Palo Verde.

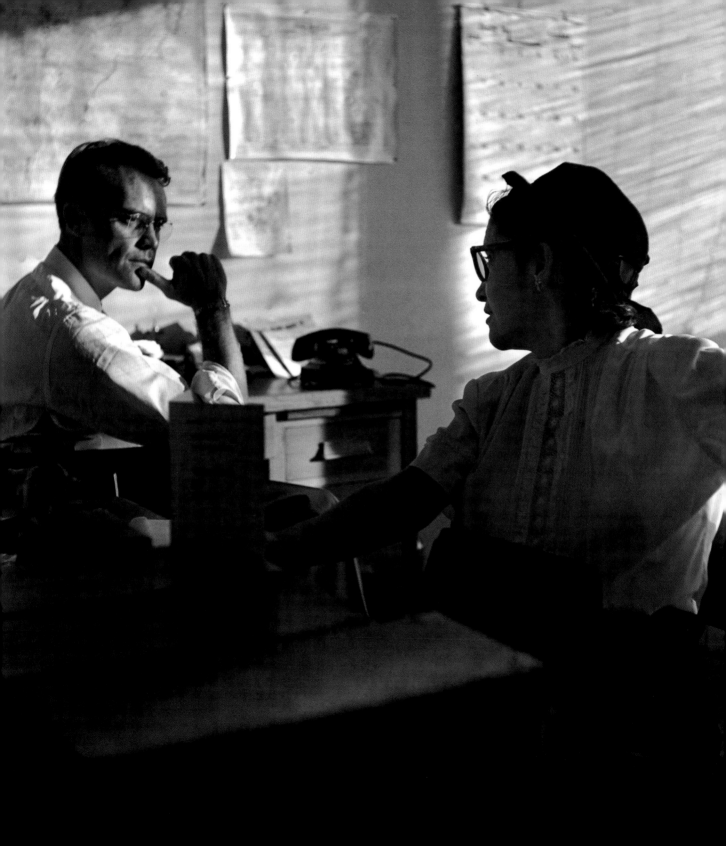

Congressman Edward R. Roybal: This is Fred Ross, and this is Maria Duran. Maria was an organizer for the Women's Garment Workers Union, and they were both active in my first campaign. These two people had in common that they wanted progress for the community. They wanted to stop police abuse. To stop, if possible, the Right of Eminent Domain. They wanted to be sure that the youngsters were able to go to school and had equal opportunity. All these were part of the program we had in the Community Service Organization. They continued their support until the day they both died.

Bill Rumble: That's Fred Ross! He was famous! He's the guy that taught César Chávez!

Fred Ross and Maria Duran discussing strategies in their store-front office near Chávez Ravine.

Carol Jacquez: We moved from Palo Verde when I was nine, in September of 1952. About the same time, my brother was found to have leukemia, and he died in December of '52. I was really angry. I had lost my home, I had lost everything that I knew, everything I'd been so happy with, and then I lost my brother. I believe that anger turned me toward political action, starting with the Chicano movement. I turned against the system and fought injustices because I felt that I had suffered a great injustice. I have benefited from the struggle. My thinking about who I am, and what I believe, was focused by that political activism. That probably would not have happened had I not felt so uprooted and at such a loss when we were moved out of Chávez Ravine.

The week before my *tía,* my sweet *tía,* died, she said, "Your grandfather was part of that *tierra y libertad movimiento!*" In the 1930s there was a grassroots movement that involved a lot of Mexican Americans throughout the Salinas Valley, and apparently, also in Palo Verde. A movement about the basics, land and liberty. And that rang a bell. It must be in the genes. Because when I first saw César Chávez, *there* went my heart. When I was working with him, my family, who had gone through the McCarthy era, were very afraid for me. And my aunt Juanita, who was raised by Miss Seeley, now an orange grove owner, said that all the women with César Chávez were whores. Photographs must give out some kind of vibes besides the information that's in them. This one zapped me right back to my organizing days.

Therese Hernandez: My uncle Murphy says that going home, walking up the hills, used to be like entering quadraphonic sound, with Mexican music coming from the radio in every house.

Albert Elias: In 1911 when my mom was about ten, her dad came to El Paso as a wetback. He had no work and no money, so he tried the border. He never returned. They don't know if he got killed or he remarried or what. He left three kids with my grandmother, and no money. That is when she sold my mother to a rich family in El Paso. That's how they got some money to survive. My grandmother sold my mom when she was twelve because they weren't making it. "I'll give you my daughter for some money and she will work for you" is how it went. She was there until she was nineteen or twenty years old. She did everything: take care of the kids, wash, iron, clean house. That is where she learned how to cook. My mom was a good cook. With the money she was making, she brought her sister and brother out of Mexico to El Paso. She really wasn't a slave. It was like a contract.

My mom would tell me the story about when she was a little girl and her dad left to find work. He was saying good-bye to the family, good-bye everybody. They lived in a little poor ranch house by a hill. He walked away. He didn't have a horse. He went for the border walking, and turned around and waved at her. My mom loved her dad so much that she used to get little rocks and put them around the footprints of her dad where he left them. Every day, she would follow them out and place little rocks. My mom used to cry when she would tell that story. Then cattle, rain, people trampling over it, and finally my mom went out there one day, and she couldn't find the footprints anymore. He never came back. The guy disappeared. And it happens right now. All these wetbacks that come here, I would say that half of them don't go back. They start making money here, they see all these women. Why go back to that misery over there. I would say half and half, they don't go back. So how do you figure that.

Workman returning to his home in La Loma.

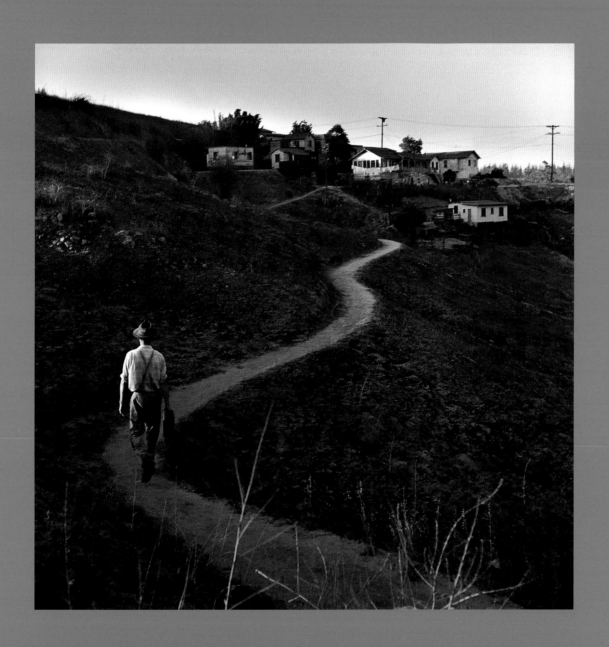

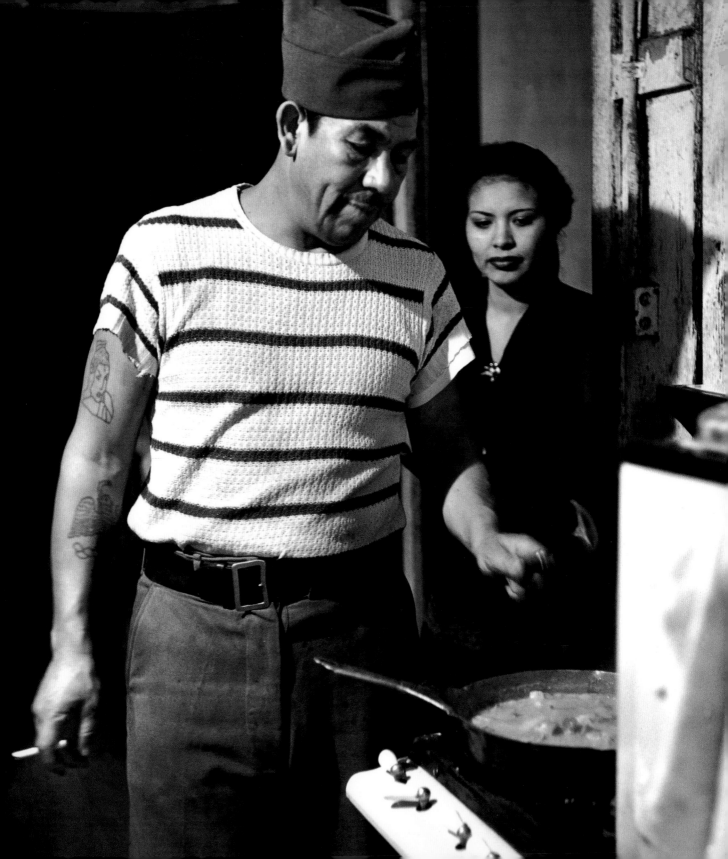

Rose Martinez: My kid's jeans, my sheets, pillowcases, everything I scrubbed in the tub. We did not have big stomachs because we walked, and we washed in the tubs, and we walked. We made a lot of exercise.

Sally Muñoz: My grandmother wouldn't let us in her house unless we spoke in Spanish. She'd say, "Don't come here with your English. Come in Spanish." I used to pout, I'd say, "I can't." She'd say, "Yes, you could." She was real strict.

{Right} *Sara Muñoz, La Loma.*

{Left} *Iladro Madrid, home from World War II.*

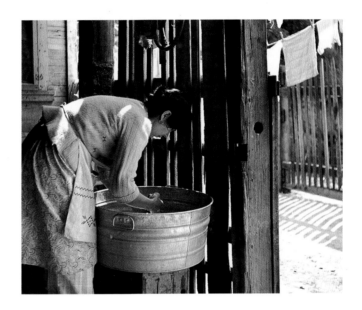

Rudy Flores: Somewhere on La Brea, they'd come and pick you up for jobs, like they do now with wetbacks. You got to get up early to go over there. Iladro had a job for a long time putting tar on the streets. His arms were like iron. He wore those wooden shoes. We'd see him come in, wore out. That's Iladro Madrid. He was in the army.

Connie Madrid: He had muscles, big muscles. He'd say, "Feel my muscle." Big, huge, eighteen-inch arms. We'd feel them and we'd say, "Where'd you get them muscles from?"

He says, "I eat roses," and he'd grab a rose and eat the rose petals. That was Iladro, my uncle.

Connie Madrid: My daddy, he was a beautiful dad for the little time we had him. He was always there. In this one my daddy looks so happy.

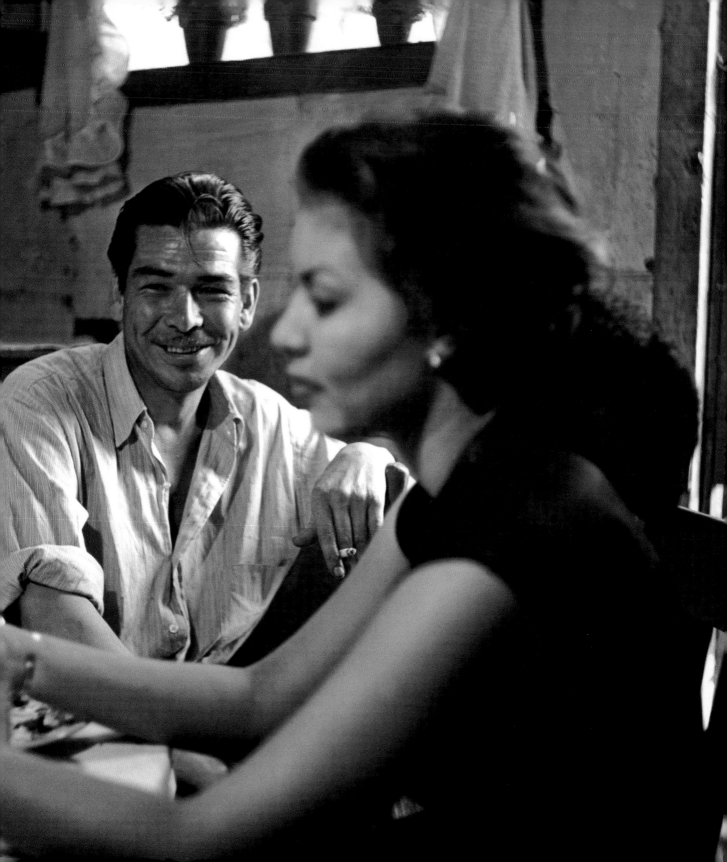

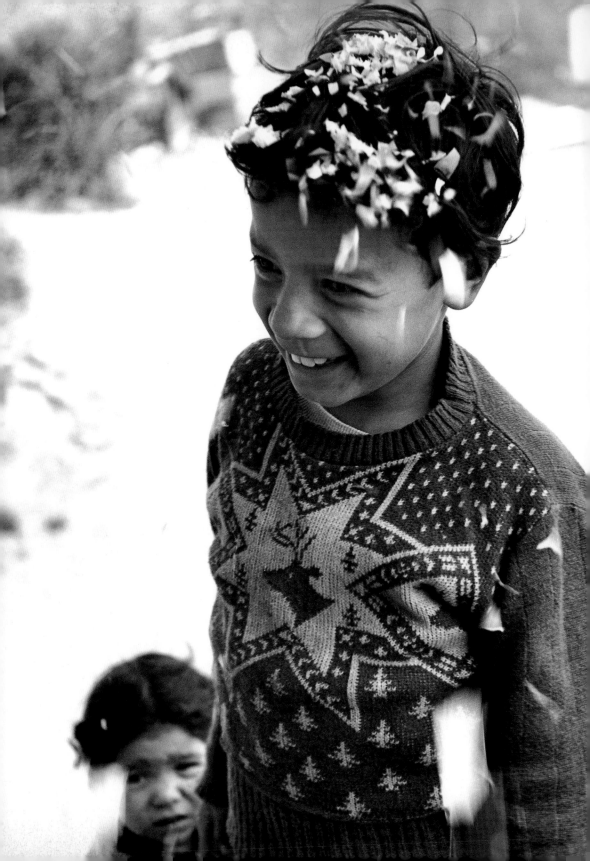

That's not snow, those are egg-shells. It's not winter, it's Easter, and someone just broke a cascarone over his head. You'd smile, too. In the weeks before Easter, eggs are opened carefully by breaking a small hole in one end. The empty shells are dried, filled with confetti and sealed with colored paper. On Easter morning loved ones are surprised with these bright egg cascarones burst over their heads.

Rose Marie Lopez: That's how we used to get ready to go in the summer, with a mattress and everything. We'd go to the peaches. When the teacher asked, "What did you do this summer?" I'd say, "Oh, I went camping all year!" I thought it was a vacation.

Albert Elias: Right after school ended everybody packed up, got in their cars, and made a convoy. A lot of families drove together just in case there was a flat or a car broke down, they had help. First stop was Bakersfield. Pick cotton, grapes, finish that. Go further up north to Fresno, Visalia, in that area, and start picking plums, tomatoes. Then go further north, more grapes. One summer, we worked the crops for three months, came back in September. We just got back in the house and my dad said, "Let's see how much money we got." We put all our money on the kitchen table. Dad emptied all his pockets, all the money he had, and my mom took all the money out of her purse and put it there on the table. They had $7.50. From the whole summer. I think they had more when we left in June.

Iladro Madrid finishes loading his car, vintage even then, for a trip to the picking fields.

Trini Hernandez: Pete, Johnny, Julio, and I picked Thompson grapes for raisins. We used to load up our cars with all the stuff for the summer. They weren't the best cars, but we'd get there. We had a lot of fun. Three years in a row we won first prize for the raisins. Everybody was real happy. The name of the farmer that got the prize was Kruger. We picked in trays that were about two by three feet. For raisins you got to pick clean and careful. We made two and a half cents a tray. When the farmer got the prize, he wrote us a letter each time to tell us he had won the prize and thanking us very much for the good work that we done.

Sally Muñoz: My dad and mom raised seven of us. They would take us up north to pick tomatoes, grapes, walnuts. We were always late when school started, about a month and a half late. I could never catch up. It got to a point where I went to school just to be going, I guess. One of my brothers graduated. He was the only one of seven that did.

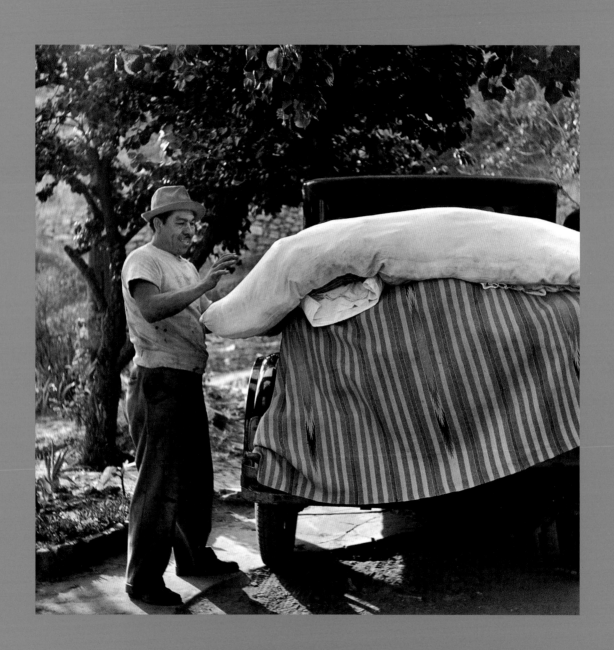

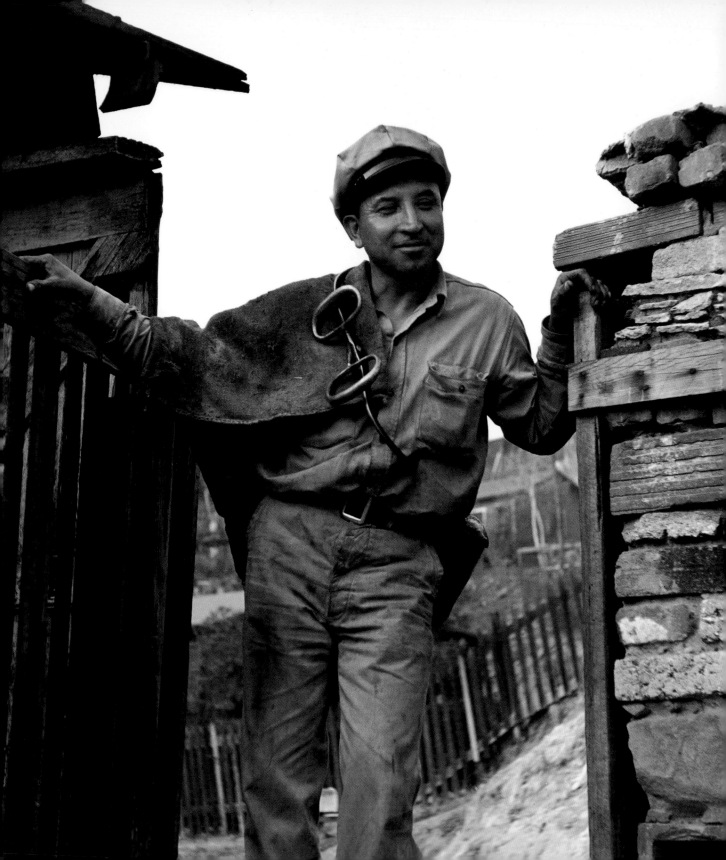

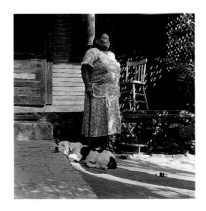

{Above} *Francisca Bantacorte and her husband's dog, Yolo Drive, La Loma.*

{Left} *The iceman with cape, tongs, and icepick holster.*

Mike Vasquez: She was big, and very, very agile. She cooked for our wedding, *gallina de mole.* She was a great cook. But she shrank from being a big lady to about little, poor thing, and she could not see then. When I would visit and start talking to her, she would say: *"¡Yo sé quien es! ¡Eres Miguel! Es Miguel."* Everybody identifies me with my voice. She tells me that I am the loudest guy in town. *"¡Mira mi tía! Mi tía Pancha."* This lady used to make delicious burritos. About this big. Full of chorizo, *papas,* beans, and chilies. It had a taste that you do not get in no place. She was fabulous, my *tía.* She was a very nice lady, but she was a little bit on the rough side.

Sally Anchondo: Our parents showed us how to cook. To make tortillas and tamales. Especially tortillas. Everyday. We came home from school and my mother had a big pot of *masa* to make tortillas. Everyday, we made stacks and stacks of tortillas. My brothers would come home from work and go for tortillas with butter. They would eat and we would hit them, "Don't touch them. We never gonna finish making tortillas." Then my other brothers would come from school and the tortillas would be going down. It seemed like we never finished making tortillas. We were always making tortillas, everyday, everyday. We didn't want to go home sometimes because we knew we had to make tortillas. My father had to eat right after work and everything had to be set on the table—the chili, the beans, the rice, the meat, and the tortillas.

Rose Marie Lopez: Mr. Mora, the iceman. He never knocked on the door, he just walked right in.

Lalo Alvarado: He gave you a sign with big numbers on it that you could hang in your window, and that he could see from down on the road. Ten, twenty, fifty pounds, and he'd cut that chunk of ice. Then he'd grab it with those tongs, put it on that apron on his shoulder, and climb up the hill to your icebox. All that for maybe fifteen cents. And down on the road the kids were trying to steal slivers of ice from his truck.

Tony C. Martinez: Mr. Mora? No! This is not Mr. Mora. This guy's smiling. Mr. Mora never smiled.

Frank Sanchez: That actor Crispin Martin, I did not like him. In the movies, he played the Cisco Kid's sidekick. He was always bragging. Sometimes in the newspaper he would come out saying that he had done this and that for the neighborhood, which he hadn't done nothing. He was a good talker. He was always putting on shows for the Lions Club or organizations like that in Long Beach or somewhere. I went with him for the ride once and he was saying these accent jokes there like, "I *thiiinnk,*" that the Mexican comedians used to say. I was sitting there while he was entertaining all these people and, oh man, I hated every moment of it. He was not well liked among the guys around my age.

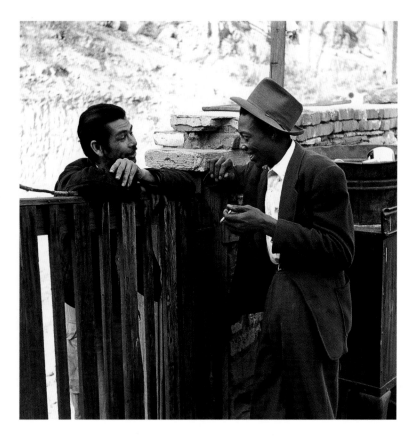

{Left} *Gilbert Madrid and Johnny Johnson visiting over the Johnson gate.*

{Right} *Louis Alvarado, La Loma.*

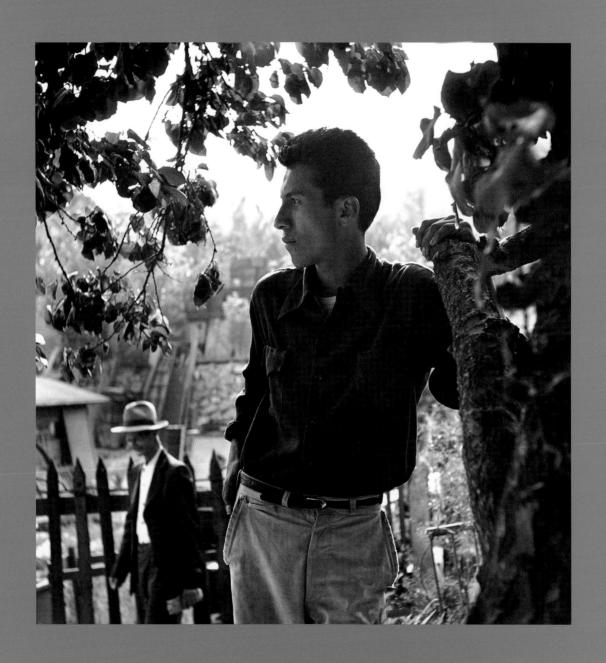

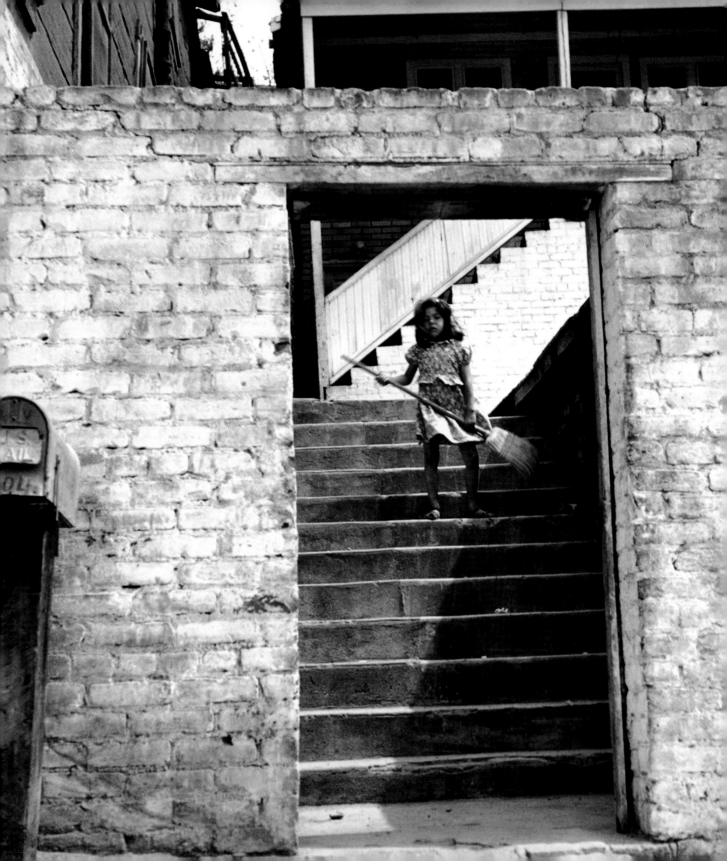

Mike Vasquez was talking about the photographs to his wife, Helen, who had never seen Chávez Ravine.

Oh, Oh. Here it is, honey! Here it is, sweetheart, the Vasquez family. The Vasquez Palace!

This poor little girl used to live in the garage. It was our garage, but we fixed it so they could live there. We made a partition so they can have a bedroom. I think this is Carmen, the little one from that family. Amalia was her mama, and her papa was Moreno. I used to feel bad for them.

After those agents came around I told my mother like this . . . I said, "Ma, they are going to take us anyway, and they are giving us ten thousand dollars right now, so the best thing to do is to sell, because otherwise they are going to scare us, telling us, 'You will not get what we are offering now!'" They were a bunch of, excuse the word, son-of-a-bitches. Because, for the simple reason that . . . they were not very nice about everything.

Reyes Guerra: Notice the coat? Look at the pants. Yeah, a zoot-suiter. He was probably an old *pachuco* in his day. He was dressed as a zootsuiter right there. Guys used to look sharp.

Mike Vasquez: This was my aunt's (Doña Martina Ayala) store right here. She used to sell soap, beans, matches; things like that. This is her house. She was the lady with the money, my *niña.* She had goats and cows and a lot of chickens. She sold chickens and she made *atole, queso,* and all that cheese, is what my *niña* did.

Nina Hernandez: When I was pregnant with my son, I had Doña Martina help with the delivery. She charged about fifteen dollars. I chose to have a midwife for one reason only. My mother had always bragged about having her children at home and not going to the hospital and not even an anaesthetic to dull the pain a little bit. I said, "I'm going to show her *I* can have a baby without nothing." Doña Martina had me visit her every couple of weeks after I was showing a lot. She massaged me to see if the baby had turned or anything else. She was very businesslike. She never left my side until it was over. I would tell her, "Oh please, let my husband be here," because he was outside waiting. So she brought him in.

"Never again will I do that," he said. "You go to the hospital next time."

Cano Cervantes: When my last brother was born in 1944 this woman came with her little black bag. We said, "Here comes the lady with the baby in the bag," and when we came home from school, my little brother was there. As far as we knew, the lady brought him in the bag. Old-fashioned parents never taught you anything about that.

Murphy Hernandez: Florencio would sit at the corner of this building all day long. I could see him sitting there now. He had them goats and everything. He used to sit there and watch his goats graze, eating all that grass. He sat there to watch this way and that way so nobody would steal his goats. But we used to get his chickens and make barbecue. We'd steal them. Everybody had chickens. "You better look for your chickens. You're not going to have any chickens tomorrow."

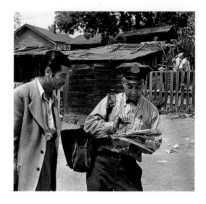

{Above} *Gilbert Madrid intercepts the postman, a neighborhood familiar.*

{Right} *Gilbert Rosales with his grandmother Doña Martina Ayala.*

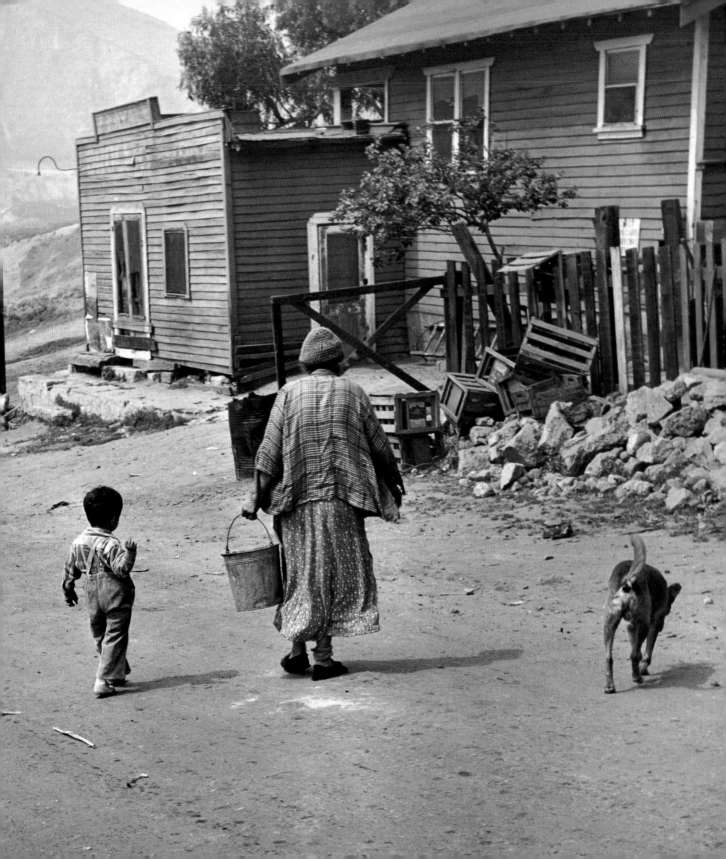

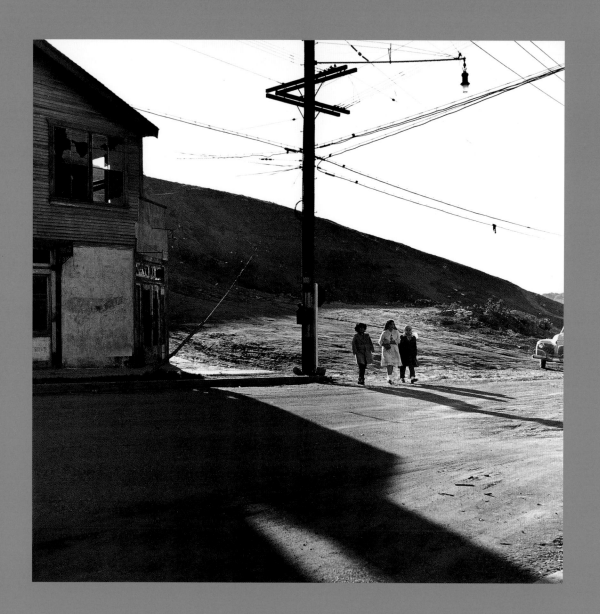

Catalina (Kate) Ortiz Provencio and Connie Ortiz Lopez:

KATE: The missionary priest would scare us all to death. We were all shaking. He would say to the crucifixion, "Look at your people." Then we had to kneel down and say, "Forgive us, Forgive us", and the priest would say again, "Look at your people." And if we didn't pay attention, mama would . . . *pinch* us. Yes, we did go to Mass. We lived in church.

There was a place in the park we called the gym because we went there for exercise. The lesbian lady would say, "All the girls wear shorts, now." So we would go to the Fuentes and take off our skirts and put on shorts. We couldn't wear shorts at home. It was a sin. The flames were going to go around you. Mama put the fear of God in all of us, but I don't think it really helped.

We cut loose. We couldn't put on makeup either because of "the flames." That picture of Mother of Mount Carmel with the scapular. Oh my God! The flames are shooting up and she is sitting there with the scapular, and all the souls in Purgatory are begging. If you die with that scapular, you avoid those flames. But if you had lipstick, the flames would come. One day I shaved my eyebrows so I could look like Marlene Dietrich. Mama beat me up and Pop said, "Leave the girl alone." Then I made my eyebrows *way* up like that. Mexican Marlene.

It was a really happy, homey community. Everyone knew each other. Everyone respected each other. The boys from La Loma would say, "The girls from Palo Verde are pretty girls." And the boys from P.V. would say, "Well the girls from La Loma are good-looking girls." Zerafin's store was a congregation place. I loved it when my mother sent me to the store. To pass by the boys and *see* all of them.

CONNIE: Jessie and I, and sometimes Carmen, used to sneak out to go dancing downtown. Coming back, we climbed the hill barefoot. We'd take off our heels, climb over the railing and through the back door. We'd go to the Avadon Bar or the Rutland Inn. I was sixteen or seventeen but I used a lot of makeup. You had to be twenty-one to get in.

KATE: Yes, you had to be twenty-one. I was only about thirteen and I was as big as I am now. Not as heavy. But I was never slender.

CONNIE: *Voluptuous* is the word you are looking for.

Three girls at Bishop Road on their way to Palo Verde Elementary School.

KATE: I wasn't voluptuous. I don't want to say it, but I was built like a brick shithouse. So naturally I had to show off. We'd say we were going to the show with my older sister Annie. She was older but smaller, so I always passed for twenty-one. Always.

Our house was like this; we had upstairs and downstairs. Very elegant *(Laughter)*. Here, our parent's room, and over here the room where all the girls slept. Then a bedroom for my brother, and down here was a cellar where my father made wine. Right here a great big kitchen. If the wind blew, the house would lean with it. As more kids were added, Papa added another room down here. In other words we had a tri-level home.

CONNIE: Papa built it himself.

KATE: He and my brother. You know the knotholes in wood? Papa would get a can lid and he would bang it up there, and no more wind would come through. We lived at 707 Phoenix Street. The Ortiz family. We were notorious.

CONNIE: No. That's not true, don't say that.

KATE: Because my mother was a *curandera.* She knew everything. If you had a stomachache, if your back was out of whack, if your leg or anything was wrong with you, she would heal you. She had loads of jars of herbs. Loads and loads of herbs. She was a midwife. They'd call her in the middle of the night and there she goes.

CONNIE: When we had stomachaches she would put some kind of powder in oil, and we would have to drink it. Once I was trying to grab a steel crucifix away from my sister. I yanked, "Give it to me!" and I got it in the eye. I still have that scar. My eyelid was hanging down like this. There was blood all over the place. My mother said, "There's nothing wrong with you." She put some powdered limestone on it. She put me to bed and gave me an ice cream. And that was it.

KATE: No tetanus shot, no nothing. A nail went in my leg once and she put a piece of cactus on and tied it around and sent me out. And we survived. We had good teeth. We never had braces or glasses or nothing. None of us. Whenever any of us had an ear problem, she would put her breast milk in there to heal it.

CONNIE: Or she'd warm garlic with olive oil and dip cotton in it.

KATE: Then you would go to school with a big blob of cotton in your ear.

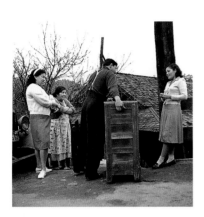

Espy Torres, left, and her mother watch their icebox being moved.

CONNIE: When I had the mumps, she put me to bed and placed hot tomatoes on me.

KATE: I got married in '39. I captured my husband. He didn't want to marry me because he was Protestant and I was Catholic and that was not allowed. I picked him up in Elysian Park and I took him. Mirabel, Genevieve, Julia, and I would go there every day to flirt. I would get up at six o'clock in the morning and mop the linoleum floor, kissing up to my mother so she would let me go to the park. My brother bought me an old tennis racket at St. Vincent, and I picked my husband up at the tennis court. We eloped and I ran away from home.

One day in downtown Los Angeles I was in the dime store looking for a wine-colored lipstick to match my dress, when an old friend saw me. She said, "Cat! Where have you been! Your father has been sick. Your mother is sick from her heart and they are dying."

I told my husband and we went to visit them. We sat there real meek. When my mother saw me the first thing she said to me was, *"¡Como eres ingrata!"* My father didn't say a word to me. Very, very dramatic.

Then my father said, "We cannot have this marriage. This is not a marriage. You are just living together. This is *El Diablo.* You can't go back with him. I am going to have this marriage annulled. And if you go back with him I don't want you in my house no more."

I was twenty. I said to Morro, "Come on Morro, let's go." I didn't want an annulment. All I wanted was him. So we walked out and ran down the hill and got in the car.

He was more thoughtful than me. "It is not good to do this to your folks because they are very nice folks, especially your father. We should get married in the church. But I don't want my folks to know." His folks were strict Protestants.

So we got married at Santo Niño Church in a dark back room like a warehouse with piles of stuff. I wasn't permitted at the altar. Father Thomas married us and so far it's lasted sixty years.

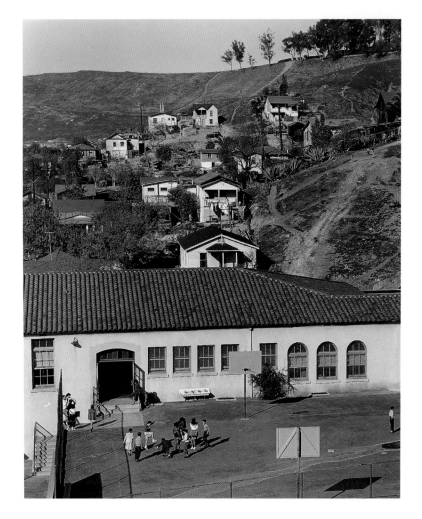

Palo Verde School was not actually demolished. Only its roof was removed. The rooms and hallways were then filled with dirt bulldozed down from the surrounding hills. The school stands there yet under the parking lots of Dodger Stadium.

Albert Elias: In church they spoke Spanish. In the store, Spanish. At the cleaners, all Spanish. When I went to school, I had to learn English. We didn't speak English at home, everybody was Mexican. We went barefooted to kindergarten, and all we did was paint and play games. They were trying to teach us the ABCs and the numbers and I couldn't understand the teacher. But in the first grade, I started right away. When you are a kid, you learn fast. By the second grade I was already bilingual, reading and writing. And the teachers, Miss Bodine, Miss Tucker, Miss Lummis, none of them spoke Spanish. My parents were proud. They were trying to learn from us. I taught my mom and dad to speak English. They could defend themselves after they learned.

Catalina (Kate) Ortiz Provencio: There were a lot of Italian people, a lot of Czechoslovakians and Mexicans and Americans. And there was no bilingual teaching. We all went to school together and we all learned English in school. From kindergarten on, we all spoke English. When I started school, I didn't know English. *Nada, nada.* At home, everything was Spanish.

Tony C. Martinez: People were poor. When women bought flour for tortillas they'd buy hundred-pound sacks because it was cheaper. One brand was *El Faro,* "The Lighthouse," another was *La Piña. La Piña* had a real nice pineapple in the background. These ladies made panties for their daughters out of the sacks. It was a joke among us kids. When the girls got on the swings, we used to watch and, "Hey, there's *El Faro* of the year." You can see the flour sack panties. "Hey, *La Piña en el aire!"* and all the guys used to run up and look. So, *El Faro o La Piña en el aire,* we'd hang out to peek, up in the air.

My mom and dad went to Palo Verde Elementary School, when they were bungalows. When I went into kindergarten, Mr. Nutt was still the principal, same man my mom and dad had. They were young, about eighteen or nineteen when I was born. When Mr. Nutt was old, they moved him down to Paducah Street School.

At Palo Verde Elementary School, a lot of the kids used to go barefoot. Fortunately, my dad always had a job and made money. We lived across the street from the school. I wanted to be like the rest of the guys, so before I crossed the street I'd take my shoes off and hide them behind a bush. And one time . . . her name was Miss Canterbury, she saw me hiding my shoes in the bushes and she said, "You go right back and put your shoes on." I had to go back and get the shoes out of the bushes. Yet she never said that to other kids. She knew they did not have shoes.

I went to college. I'd walk out of there with my books and get on the streetcar. I felt funny, carrying that load of books down Bishop Road every day. Kind of sneaking out past all the eyes in the neighborhood. Coming back late one evening when the sun was low, I saw the guys hanging out at a bend in the road. The head guy crooked his finger at me and said, "Tony, come here a minute."

My head was down. I was thinking, "Uh-oh."

The guy put his hand on my shoulder and he said, "Tony, we wanted to let you know we're glad that *some*one from here is going to college."

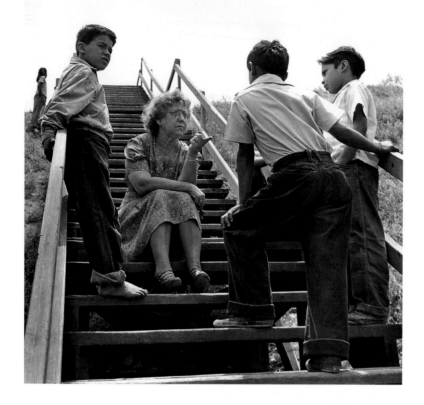

Alicia Arevalo Baca: That's Miss Morgan. She was mean, but she *taught* us. She's bawling *some*body out. She made me write my name over and over on the chalkboard a hundred times. They were mean, but they taught us. They meant well.

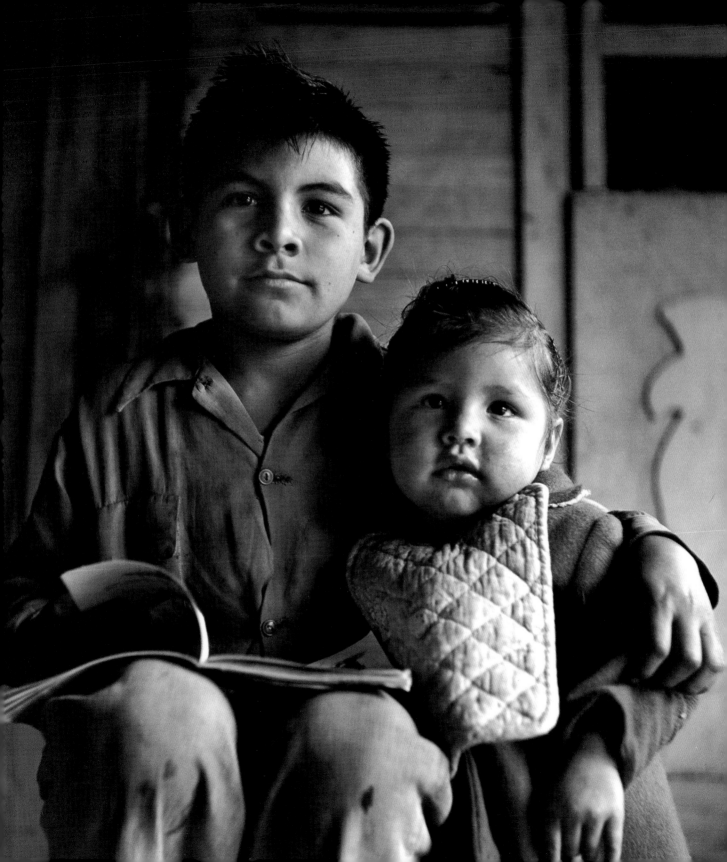

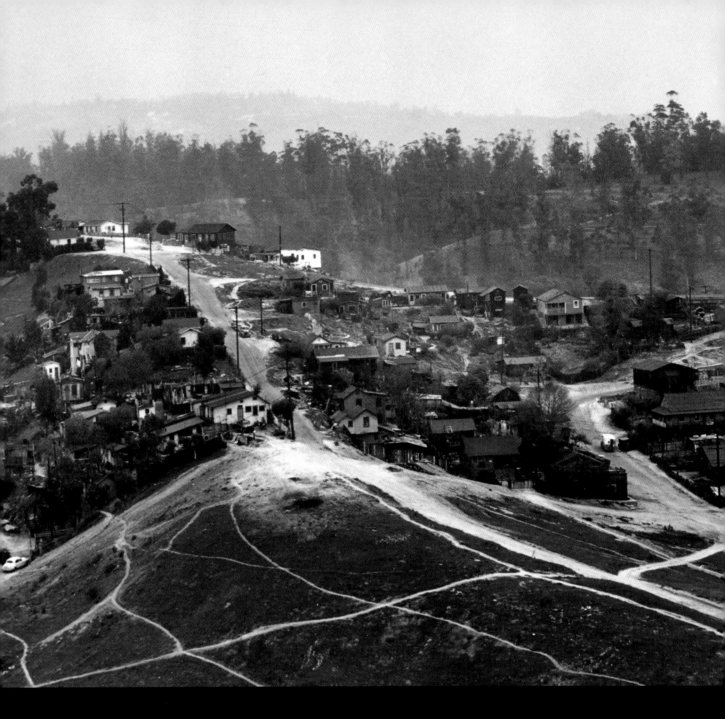

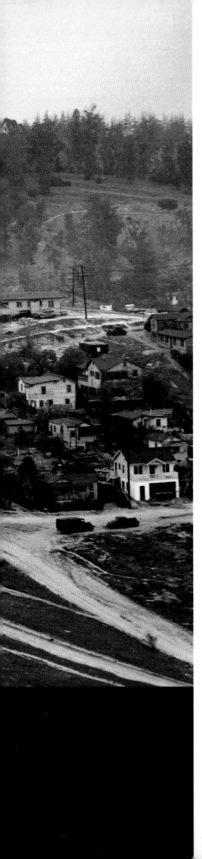

Sally Muñoz: In Loma, anything that went up there loaded came down empty. We had only one streetlight in Loma, and that was where everybody would party Friday and Saturday. Whatever the guys decided to do. They would connect the wire to a big jukebox. That was stolen, too. We had Glenn Miller, Artie Shaw. The guys would connect it to the pole and we had the best jukebox in the world, and everybody'd be dancing up there under the only streetlight we had. We had a real good time. We had happiness.

Henry Cruz: It wasn't Brentwood or Beverly Hills, but we were happy people here in this neighborhood. A lot of fond memories here. Now it looks like a ghost town or a mining town. But beautiful, right? Beautiful.

Mike Vasquez: This is Yolo Drive, going up. An old man named Don Tomasito lived right in here. He would come selling Mexican bread. He carried it like this, on his head. I never did go back. . . . The only time was when there was a championship fight in the stadium the Dodgers had already built. It was a big fight and it was raining and storming fierce. I came in from Solano Avenue, up Academy Drive all in the storm, and then I parked. And you are not going to believe it, but I was parked in my neighborhood. I was parked right in my *house.* I could see that the reservoir was up there . . . and I remembered where it was. Don Tomasito lived right there, I know. And my *car* was in my *house.* That was the fight when the Cuban boxer got killed.

Zeke Contreras: There were fighting families there at Chávez Ravine. Every street had a professional fighter. On Paducah, Lou Bernal and Ruben Jimenez. On Gabriel, Baby Arizmendi, lightweight champ who fought Henry Armstrong three times. Also on Gabriel Street, there lived a guy named Serna . . . I believe he was a champion for the state of Arizona. On Bishop, there lived Mendez, a light heavyweight. He was also a professional fighter. He showed it on his face. He was ugly and had cauliflower ears.

On Reposa, Carlos Chávez. He was the state champion for three years and fought Manuel Ortiz, who was the first Mexican to be a champion in the bantamweight division. He was the best bantamweight ever. Carlos beat him twice. They fought three times, fifteen-rounders. And Carlos lost by a split decision. He fought with him in a twelve-rounder and won. Then he fought for the championship and lost again. He then decided to *beat* this guy and trained hard and fought Manuel Ortiz and won. He was only 118 pounds and went to the division at 146 and fought Art Aragon, who was considered the golden boy of boxing.

One of his last fights was against Bill Kim, a guy from Hawaii. A rugged individual. I felt sorry for my friend Carlos Chávez. Kim looked like a gorilla compared to Carlos. But Chávez beat the hell out of him. Even at that weight. Chávez was something else.

I was about seventeen, same age as Chávez, and I wanted to box, too. He trained near my house and I would join him and do road work. He ran from the Arroyo Seco freeway, across Stadium Way, all the way to the end of the park and back. When he was fighting fifteen-rounders with Manuel Ortiz, he would run to the end of the park and back and do it again. But that was too much for me. I wasn't the one fighting the fifteen-rounders.

The last time I saw Carlos Chávez was at a picnic rendezvous three years ago. Ten days later, he was held up at a market. He fought back and there was a guy in a car with a shotgun who shot him and killed him.

I am seventy-five now. I would like to have boxed. I played with professionals and some told me I could beat the man who was then the flyweight champion of California, Kenny Duran. But I was getting into kites. I've had big success with my kites. My eagle kite with ten-foot wingspan has won every competition it's entered.

While looking at this photograph, Lalo Alvarado told me that a pair of great masons had left their mark all over La Loma. He said that Atilano Adame and a guy named Francisco had built up retaining walls everywhere.

I said, "You're talking about those stone walls in the background? What about those guys in the picture? Who are they?"

Lalo said, "That's just Gilbert Madrid and Louis Alvarado fooling around."

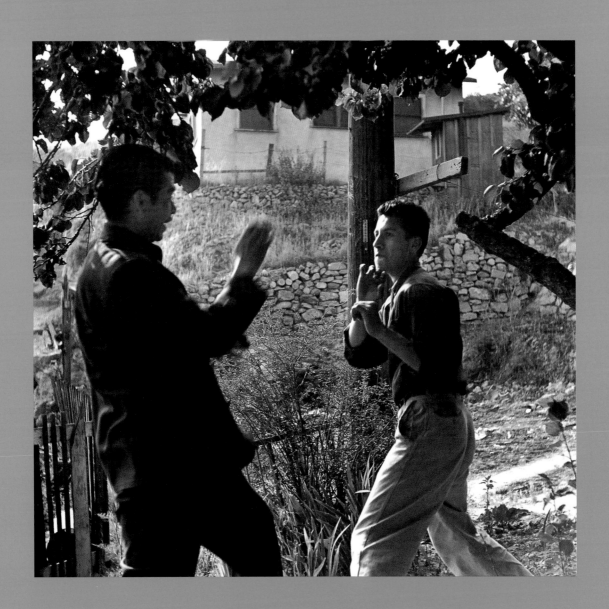

Vince Delgado: The police were really mean then. If the laws were the same then as now, police would have been in a lot of trouble. I saw them beat a Mexican kid from Palo Verde. He was handcuffed in a SWAT car and somebody opened the door and he ran out. They caught him (running, hands cuffed behind him!) and they beat the heck out of him. Kicked him, hit him with the sticks, and people were saying "Stop it! Stop it!" and they just called for more police and never did stop. I don't know what ever happened to him. I'd get stopped sometimes and they were just plain mean.

In school when there were fights and it was my neighborhood, they'd say, "Come on, you need to join in."

I'd say, "No, I do not need to join in. I did nothing to the guy and the guy did nothing to me. If I want to fight, I'll fight somebody that's done something to me. I do not need you."

They had gangs, but they really never bothered anybody. The guys used to drink or smoke pot. I never saw them with needles or anything like that. I never saw them with guns. If anyone wanted to fight, they fight with the fist. In regard to drugs, some guys asked me to try it, and I'd say, "No way, I don't want to try it."

And they would say, "Oh, you are a queer or a sissy."

I'd say, "Call me what you want, I don't care." A lot of these guys got into drugs because someone said that they are not tough enough. Maybe they never bothered me because my uncle was Carlos Chávez. My uncle was fighting then and he was a tough fighter. So they did not mess around with his family.

When I was fifteen or sixteen years old I started learning to box. I trained at Main Street Gym after school. If I did not have money for the streetcar, I walked home. I used to run on the fire roads in Elysian Park after school. When I got out of the service after Korea, I started running there again. I liked it. Going up there about seven o'clock in the morning. Nice and fresh.

In Johnny's Barber Shop where I used to get my haircuts, I was looking at this *Life* magazine, and the customer ahead of me got up and left and I told the barber, "Johnny, hey, was that the guy here in the paper?"

He said, "Yeah."

Jesus Christ, he looked like a real nice man. He was the main mafia godfather here. When they offered me a shot of being on national TV, I said okay. They said we'll pay you $5,000. Out of that, you pay $2,500 back to us and we tell you whether you win or lose. So I said, I don't want it. You can keep it. I will fight for less, but I will not do what you want. So I never fought on national TV. A lot of those fights were fixed. They would tell you what to do. Five thousand dollars was a little bit more in the fifties, but still it wasn't that much money. From the $2,500 I'd keep, you still had to pay your manager his third, the gym and the trainer, the partners, and at the end you would come out the same without doing what they told you. Just no national TV. I said no.

Frank Sanchez: We guys from Palo Verde and the guys from La Loma used to bullshit a lot when we see each other. We would greet each other and talk at parties or whatever, but that was about it. They had what they called Federation Dances at the Bishop playground, or sometimes at Solano School. We would go in there and mess around and drink beer and blow weed or whatever and dance. A lot of girls from other neighborhoods came, and that was how we communicated with each other. See each other at the dances or meet down the street. We bullshit and so on, but that was as far as it went. I never did hang around with Loma guys much.

Federations were formed by a probation officer, Manuel Bonda. He was a good man. They were having the same problems as they do now as far as gangs. They would try to get inside with the gangs, try to know them and form these little clubs in each neighborhood. After they formed a club, they would have these dances and see if one neighborhood could go into another neighborhood without having no hassles or fights. See if they could make us more familiar with each other so we wouldn't be fighting.

When we did fight, it was mostly bottle fights. We'd throw bottles at each other, rocks mostly, well, maybe knives here an' there, not that much, but guns, you wouldn't hear too much about guns. Maybe one or two guys had them in one neighborhood. In Palo Verde, only about two guys that I know of had guns. Not like now. It seems like everybody has them now.

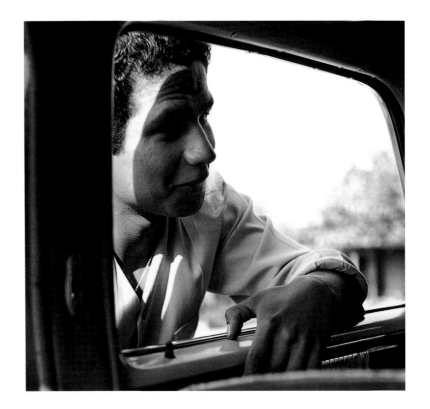

Kiko Rivas. In the year after this photograph was made, he killed another young man, Leo Perich, a friend who teased him too much. They were drinking. Leo had a baseball bat, and Kiko had a knife.

Henry Cruz: Kiko. He's gone. Reyes's friend, Bobby's friend. Real good friend. He lived a hard life.

Frank Sanchez: With Kiko, when we were standing on the corner together drinking and he got a little high, he would get ready to start a fight. I got into music, and I used to take him with me. At that time they had those stage shows downtown. We would see the shows and once in a while I'd take him to hear different concerts. Later on he got a car, so it was much easier for us to move around and hear the music. I wouldn't call him a troublemaker; he was a good kid. But he is one guy you wouldn't be able to play around with because he was pretty good with his hands. He was quite a boxer. Yeah, good old Kiko. He died a few years ago. He was living with this girl named Shirley. As he got older, he still had that habit of talking real loud. But that's about it, talk loud. He kind of settled down and didn't go out too much. Shirley wouldn't let him. When he passed away, she took his remains back to her reservation, up in the State of Washington.

Tepi Hernandez: There was a funeral by the mountains and we saw him [Dormido] and he's homeless. He went up there because the guys were looking for him. He lives under the bridges. You can't recognize him, all dirty. He was at the funeral, but they did not let him go in. At the cemetery he was far away from everyone. There was a lunch after the funeral. They told him to stay outside. Nobody likes him over there. He went into the houses and stole.

Reyes Guerra: We were coming from a dance over in Alpine. This guy was playing with a gun in the car, leaning out, shooting in the air. I kept asking, "Let me shoot," but he said no. At the park we all got out and this guy was shooting again, but not at nobody.

I said, "Let me have it."

He said, "No, don't touch it," and we were both pulling and the gun went off.

I sat down. Manuel came running and said, "What happened?"

"Nothing," I said. "He didn't shoot me. He missed me." By that time I couldn't get up and this guy, he ran away. It didn't hurt me, I didn't feel it. It was just like somebody hit me with a punch. I didn't know that I was shot until my brother opened up my shirt and I was full of blood. I was lying down and they were trying to pick me up, and I said, *Viva la Bishop*, I thought I was dead.

They put me in the car and on the way to the hospital the car broke down. I remember a taxi and lying somewhere, and I see my brother and the guys running up some steps at a hospital. There was a lot of cameras and guys taking pictures. Then I was on a stretcher and the doctor was asking me, "Do you feel like you're going to die?"

I said, "What does that feel like?"

He said, "Do you want a priest?"

And I said, "Yes," and I passed out. I was eighteen years old. When I woke up the priest was finishing his reading and was about to leave and I grabbed him. I was holding onto him. I didn't want him to leave.

When I woke up the next morning a man was coming through the door with a newspaper. He was saying, "Is this the boy? Is this the boy?" In the paper it said it was a gang fight. I don't know why they put it like

{Right} *Charolito and Dormido. Charolito died of a drug overdose. Dormido, who got his nickname because "he had these long eye-lashes and these real dreamy eyes," disappeared. The story is that "he fingered a pusher, there was a contract out on him, and he left the area."*

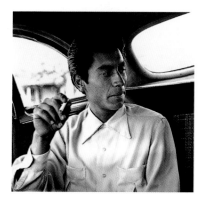

{Above} *Juan Alvarado is remembered for a good voice. He was one of those who, with guitar, sang Mexican serenades from the water tank in the small hours of the morning.*

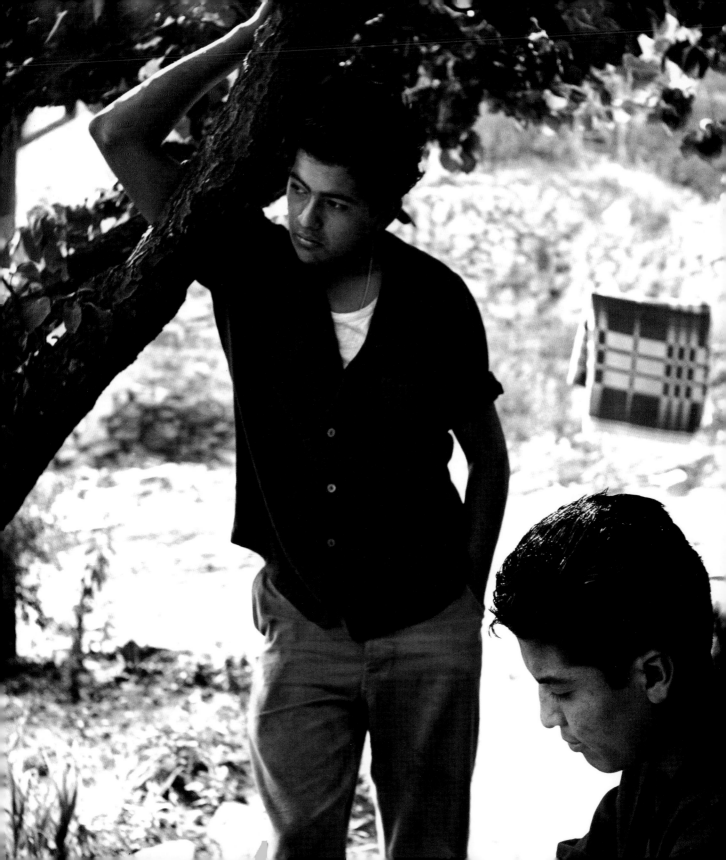

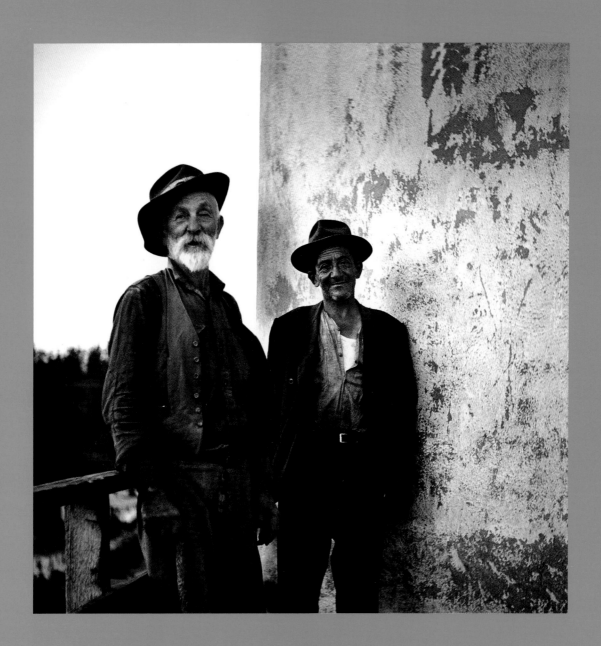

that, but it was no gang fight. There was no misunderstandings. It was an accident. The newspapers wrote a lot of things like, *"We're going to retaliate," "Gang Fight in Elysian Park erupts again."*

I don't remember ever any gang fights around here. Never. Well sure, we had misunderstandings, like Loma, Palo Verde, Bishop. But there was never any, "We'll meet you guys over there," or anybody shooting. It was a time when I dressed as a zootsuiter, but I was never in a gang fight. Neighborhoods like Alpine and Macy, where they were rivals, *they'd* fight it out, but I never seen it. Or Loma and Clover, they were always at it, but I never seen them in a gang fight. I was never involved, so I can't say anything. . . . But, *Viva la Bishop.* That was my neighborhood.

Pete Urrutia: The store was owned by the Ramirez family and run by Genaro Ramirez. They called him Jerry. He sold beer and wine and not much else. He'd sell to us kids, twelve or thirteen. He'd go out the door, look around . . . you could see all around from up there, see any cops coming. And he'd come back in and say, "Okay, get out of here." Sometimes dads, climbing the hill home from work, would send a kid running ahead to buy 'em a beer.

Mr. Perich, an Austrian (left), and
Luis Ortega, at the liquor store.

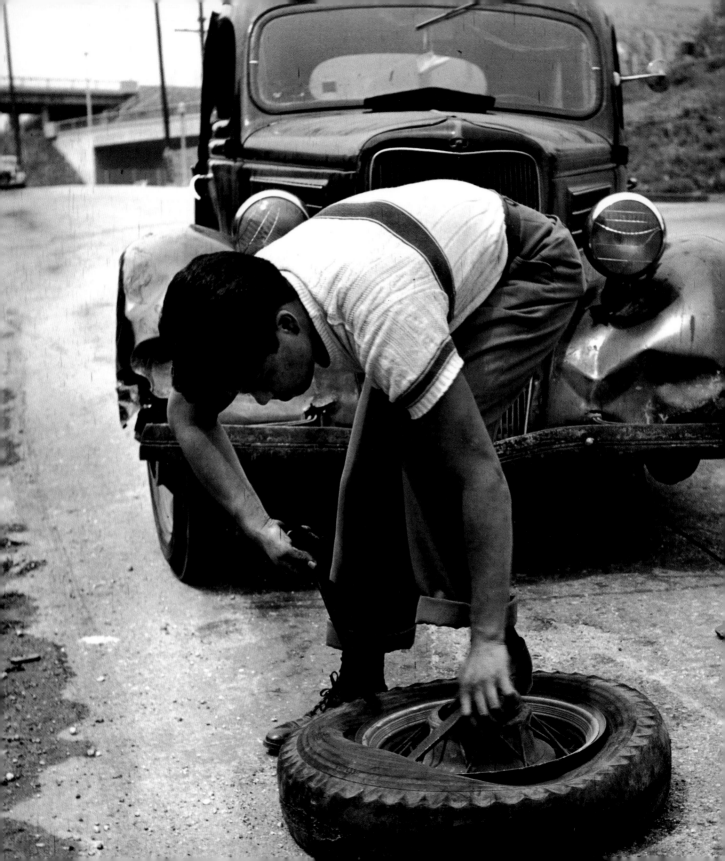

Henry Cruz: Moti was known for all the time stealing cars. You'd say, "Hey Moti, where'd you get the car?"

He'd say, "My uncle let me . . ." Huh-uh, he stole it. But if he stole this one, I don't think he'd be fixing the flat.

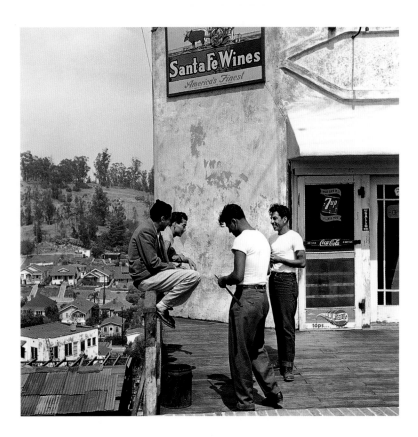

From left, Tony Rosales, John Vasquez, Carlitos, and Murphy Hernandez at a regular meeting place in front of Genaro's store.

Marciano (Murphy) Hernandez: That's Jerry's liquor store, the place where we hung out. Let me put my other glasses on. Now I see. This is Carlitos and that's me. You can see part of this tattoo here. Now it's clear. Chuy and them. We were the main guys. Chuy, he died in the joint. They buried him over in Forest Lawn.

One time they were looking for Leo and Bimbo. They had jumped bail. A bail bondsman caught them over here at Dead End. He was driving and he had Leo and Bimbo in the back seat, handcuffed. They were coming down like this and right here you pass the liquor store. There's a brick wall there and Bimbo got over the front seat and turned the wheel real fast and the car went over the wall and tipped over and they crawled out. The man was hurt and laying there, and someone called the ambulance. They both got away handcuffed. Later on they got caught. And later still, Kiko killed Leo in the park. That's a good picture. Kiko used to be a runner for me when he was just a little kid.

My son, the priest, says, "Dad, how come you and Mom never went to school?" He don't know. I gotta explain it to him. We didn't have no money, no clothes, no transportation.

One time I donated a year of my life to the probation department. I had two kids under my wing. They did pretty good. But then I started getting sick. I couldn't deal with it. I did do them some good. I am thinking about going to a place in Whittier—it's like a little San Quentin—and start there. Talk to them kids, tell them about my life. I come straight. They listen to me. We sit in a room and just talk things out and I tell them deals I had to go through and the suffering I caused for nothing. It didn't pay. I told them that I was in the bottom of the barrel and I pulled out of it, and that anyone who's in here is a damn fool. "But anybody who can get out is a man," I'd tell them. "You work in here for nothing. Why don't you get out and go get a job. And those who are taking dope, that is why they call it dope because it's only for dopes. Foolish. So young and ruin your life away. You say you got no parents. I didn't have no parents. No father. You can't start on that crap." Some of them send me letters later on that they are doing alright. One of the guys under my wing stood on the ball. He did beautiful. He got a job. He is doing alright. He was honest. But he was from the other side, from Mexico. They pay more attention. These guys here, they have it too good. Too easy. Everything is put in their mouths, these guys today.

I get like a dog, you know, seems like you smell them. Because they are up to no good. Bunch of guys hanging around. The cops should do . . . they are doing it now, though. When they see three or four guys together, "Hey, break it up!" What the hell are they doing in the middle of the night in little gangs. Up to no good. Put the parents in jail. They brought them into this world, take care of them. A cat takes care of its kittens. One time, my cat had her kittens way up on that hill. It was raining like hell. The cat brought them one by one all the way down to my mother's house where it was dry. So a human being should know better.

What I remember are the roses in my mother's yard. She's been dead twenty-two years now. Sunday, I went to her grave. I am not bragging about it. Something makes me go there every month, go see her grave. I have roses back here. Every time I cut some, I take them over there because she used to love them. I pray for her.

Albert (Beto Calavera) Elias: When I was about five or six I'd see them bring the prisoners to work on the police academy from Lincoln Heights jail. Those prisoners were electricians, plumbers, cement finishers, whatever. We lived on the corner where their bus turned every day and I'd see the prisoners, but I didn't know who they were. So I asked my dad, "Who are those men that come in the bus everyday. Where are they going?"

My dad said, *"Esos son calaveras.* Once you are in prison, you are a dead man to society. You are a *calavera,* a skull."

The next day I was sitting on top of our retaining wall and I see the bus coming up the street. All the windows were open and the prisoners were in there and most of them were Mexican. When they were turning the corner I yelled, *"Calaveras!"* They all knew what I meant. They got mad, but I knew that they couldn't come out of the bus because the policeman was guarding. The more they got mad, the more I enjoyed seeing them get mad. Everyday I used to yell, *"Calaveras!"* I know they hated me.

One day we were going to the store and our old neighbor was sitting on his front porch, and he called to me, "Hey Beto Calavera!" The kids heard that, so they started calling me Beto Calavera. It stuck. Some of the guys from the neighborhood come to my shop and they still call me Beto Calavera. It will stay with me until I die.

Gilbert Madrid. His nickname, No Te Congojes, translates as "don't be distressed."

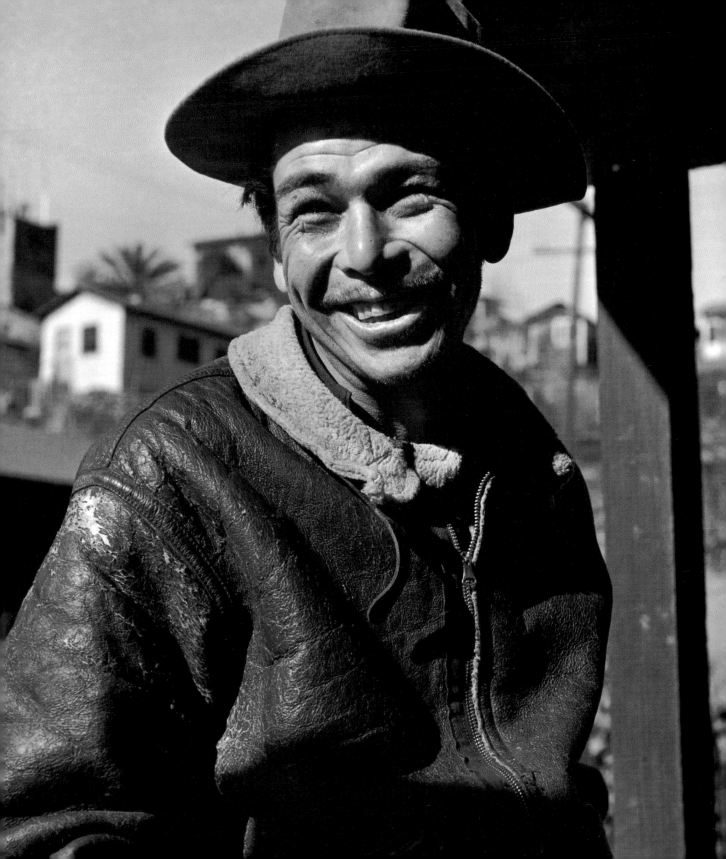

Acres
Arky
B-19
Baby
Beaver
Ben Turpin
Beto Calavera
Bimbo
Blackie
Black Bill
Blackstone
Bola
Boodie
Blue Moon
Bubbles
Buckwheat
Bugs Bunny
Buttermilk Sky
Cakes
Cali
Cano
Captain Marvel
Cara de Tabla
Cara de Caballo
Cara de Papa
Casca
Catos
Chacha
Chachi
Charal
Charalito
Chava
Chavela
Chelo
Chema
Chente

Chevero
Chevie
Chevo
Chickie
Chila
Chino
Chiquillo
Chito
Chunchie
Chuy
Chuy la Baca
Cisco
Clipper
Coco
Cochepa
Conco
Cowboy
Coyote
Cropo
Cuni
Cunini
Codo
Cunco
Dodo
Dormido
El Cementerio Andando
El Chavacan
El Dopy
El Fumajo
El Griton
El Guero
El Mion
El Mosco
El Naranjero
El Nido
El Niño Robles
Esqueleto
Flaranfinflaranfla
Fifty Cent Ernie
Fili

Fito
Fugie
Fuie
Froggy
Gacho
Gaucho
Godie
Goofy
Guardapedos
Gunga
Ham
Hara Hara
Hendra
Huero
Hollywood
Hoyo
Jazzbo
Jimmie Nico
Joe la Plano
Juana la Marrana
Juan Botas
Juan Camisas
Juan Te Pelisco el Hoyo
Juanito
Junie
Kekito
Kicito
Kiki
Kiko la Butch
La Baca Sonada
La Bouncer
La Gañoso
La Gata
La Gorda
La Huera
La Living Monster
La Loca
Lalo
La Pererra
La Pocha

Largo
La Ronca
Las Changas
Lefty
Leka
Lepe
Lichita
Lolie
Lon Chaney
Louie Beans
Louie Ponies
Machine Gun Benute
Millones
Mon
Monho
Monie
Moti
Murphy
Nando
Nanie
Negro
Nena
Nene
Neta
Neto
Ñoño
No Te Congojes
Old Buttermilk Sky
Pablito
Pacho
Pachora
Pachuco
Paco
Pajaro
Pajarito
Panchie
Pancho
Panchito
Pancito
Parra

Pasty Cogan
Pati
Peanut
Pegleg
Peewee
Pelon
Pelonie
Peludo
Penguin
Pepe
Petra la Perroda
Pichon
Pilia
Pio
Pipas
Pipo
Pispi
Pito
Pocha
Polin
Pollyseed Molano
Ponchie
Poyo
Punkin
Punky
QTP
Queena
Racoon
Ripo
Ripper
Sambo
Sapo
Sarco
Savitas
Search Lights
Sewer Pipe
Shazam
Shy
Silent Joe
Somehow

Sonny
Sopas
Speedie
Spikie
Sprinas
Steel Wool
Tacho
Tachito
Tar
Tarzan
Tero
Tigere
Tini
Tito
Tivo
Tolina
Tom Mix
Tomato
Totie
Tony Gordo
Tony Sapatero
Topo
Torpe
Toro
Toto
Two for Nickel Donuts
Two Gun Brooks
Two Ton Tony Galento
Vacho
Vevito
Viblo
Vola
Vucho
West
Wechie
Weward
White
Willie 77
You Bet as Will
Yuyen

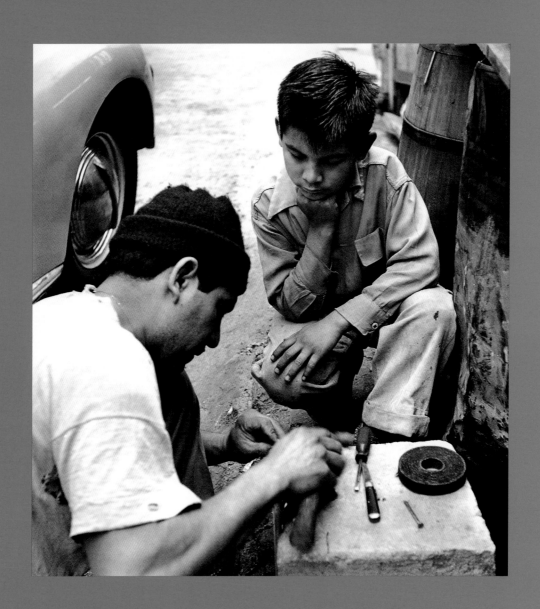

Manuel Muñoz watches his father, Manuel, work on his car with minimal and improvised tools.

In 1948, problems were developing with children from Palo Verde who lived near the police academy. Some were trying to sneak into the academy swimming pool, others were playing in the fountain, letting air out of tires, or committing other such nuisances. To help avoid trouble for both the kids and the police, Julio Gonzalez was assigned to form a Deputy Auxiliary Police club, the fifteenth such program in the city. Julio, in uniform, went knocking on nearby doors to tell parents that he was starting a boys' club and asking that their sons join. Only five boys showed up for the first meeting, held in a classroom at the police academy. Julio's wife, Julie, and their five-year-old son, Steven, also came to meetings. Julie's job at first was to look after the littlest boys. Soon though, a small girl was tugging at Julie's skirt and saying in an angry voice, "When are you going to make a club for us?" There were soon about fifteen boys and girls who met once a week, saluted the flag, paid five cents dues, and had fun. They swam in the police pool, played volleyball and touch football, and developed a pretty good baseball team. Meetings often ended with a trip in a police bus to the nearby Carnation ice cream plant. A trip to Zuma beach for a weenie roast would fill the bus. At the beach, five-year-old Steve had a flashlight. If couples drifted away from the fire into the surrounding darkness, it was his job to follow them with the light, and tell them that Momma said to come back to the fire.

When Julie, asking kids about birthdays, learned that no one ever had any parties, she quickly made a birthday list. New sweaters became the standard gift, and she found a source in a local manufacturer. More help came from other local businesses. Baked goods came from Van de Camps, soft drinks from Nesbitt. There were passes to the Ice Follies and end zone tickets to the Rams. Signal Oil Company opened a camp in the Sierra and invited Julio's kids. At the end of a bus ride, children hiked for two and a half hours into the remote camp near the Kern River. Fifty or sixty kids out of Palo Verde made this trip each summer. They ate well there. Camp had its own merit badges, earned by learning the names of trees, by catching fish, and other exotic accomplishments for these kids.

At club meetings rumors began to circulate that something was going to happen to the neighborhood. When the eviction letters came from the housing authority, Julie says, "The children came to us crying. Saying, 'They want us to move. We don't want to leave. Can't you do something?'" Nothing could be done. The club was disbanded, but has never been forgotten.

Julio still remembers those Palo Verde kids. Tony Frias is a neighbor in Long Beach. Dickie Dagenpatt graduated from Annapolis, and Julio regrets yet that he had to decline his invitation to the graduation ceremony. Angel Gaten is a retired policeman, Dickie Martinez has retired from the gas company, and Beto Elias does well with his radiator shop in Bellflower. Nestor Novoa opened a beauty parlor in Beverly Hills. Father John Santillan was one of his boys, as was Lou Santillan, head of Los Desterrados and honorary mayor of El Sereno.

Julio was given several testimonial dinners at his retirement. The biggest was at the police academy. Over five hundred attended, mostly former residents of Chávez Ravine. Ricardo Montalban was master of ceremonies. Julio and Julie are both remembered with absolute love.

"Those kids needed somebody real bad," says Julio.

"He was teaching us how to be Americans," they say.

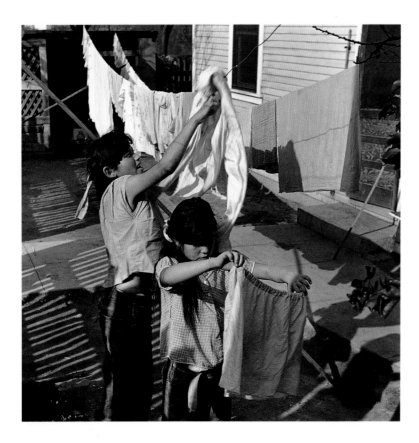

Big families meant a lot of laundry. Girls were responsible for many household chores, such as hanging out the wash.

Eleanor (Cano) Cervantes: We were a big family. My mother had a baby every year. My dad would buy a hundred pounds of beans, a hundred pounds of potatoes, and a hundred-pound sack of flour, *La Piña* flour, to make tortillas. Mostly they were big families up there. There was a big production of kids until during the war when the husbands were overseas. My mother never, never went out. The only time was on Saturdays when my dad went to Central Market with her to buy the groceries. Buy fruits and vegetables and come home, and that was it, the only time when she ever went out.

Mother made our clothes. She'd cut out a skirt, cut a sleeve, just measuring with her fingers. She measured with her fingers how long the blouse was going be. She sewed really pretty, too. I learned a lot from her. How to cook, how to sew. Not how to save money, because I don't save. We cooked for San Conrado Church every Sunday.

I worked in the cafeteria at Palo Verde School. My sister used to bake the best lemon meringue pies because she learned from the cook at the school. I danced the Ballet Folklórico at Solano School with Mary Hilda Navarez and Julia and Margaret Navarez. Their mother taught Mexican folk dances. My mother couldn't afford one of those dresses, but we'd borrow one, then I could dance. I fought the boys at school. Yeah. They used to pick on me because I was always heavyset. They made fun of me. I'd sock them and give it to them. I fought almost every day in school.

Mary pierced my ears when I was about seven, me and my sister, Chacha. We didn't have earrings then, but we put a little red string in. I really did enjoy my growing up there. We'd go to the park with the guys and sing. We sang *"Por un Amor"* and *"Qué Suerte la Mía," "La Feria de las Flores,"* all those old songs.

My dad nicknamed us all. My brother Pete, he called "Catos." Carlos was "Cali," Candelaria, "Chacha." Grace was "Bola," and me they called "Cano." Nobody knew our real names. Victor Maldonado was called "Tarzan" or "Racoon." Everybody had a name. Froggy, Gaucho—all those guys.

My sister tattooed me when I was about twelve. We didn't have nothing better to do. My parents were very angry. I got independent when I was thirteen years old. I was the first one to start putting on makeup and going out, and I had sisters older than me. I was the black sheep. I quit school in eleventh grade and started working.

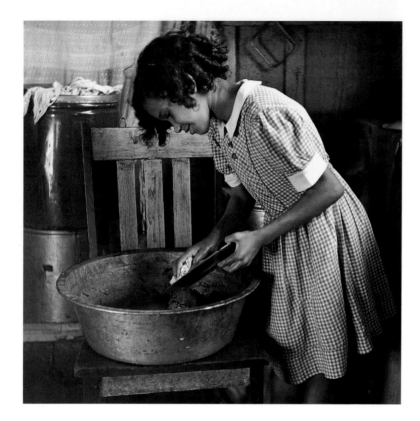

Cano Cervantes: I remember Elinor. They lived in Bishop on Davis Street. Elinor played the piano so beautiful. That was the only black family in the neighborhood. I forgot their last name. We used to love to go hear her play the piano in her house.

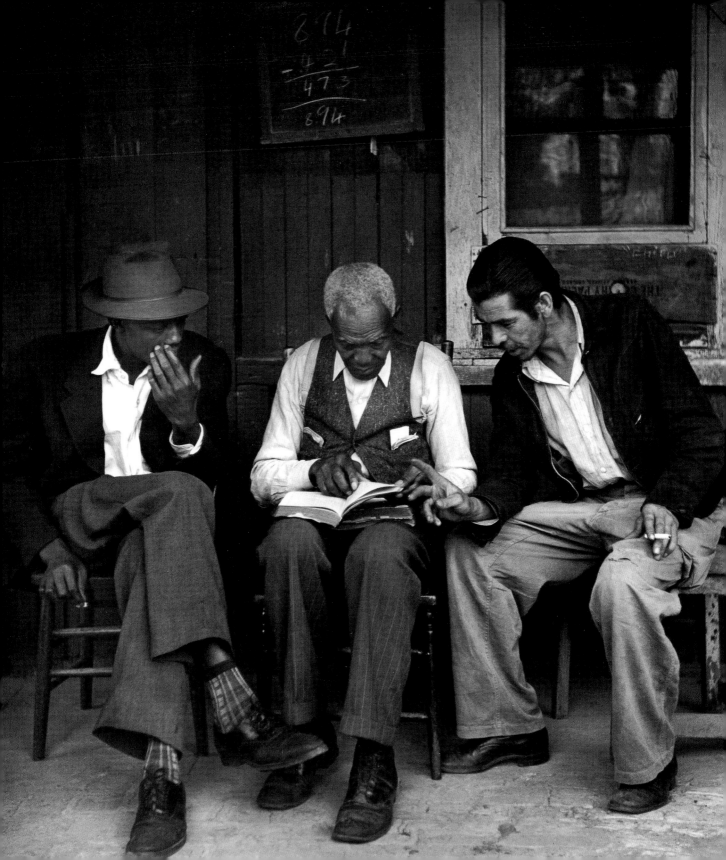

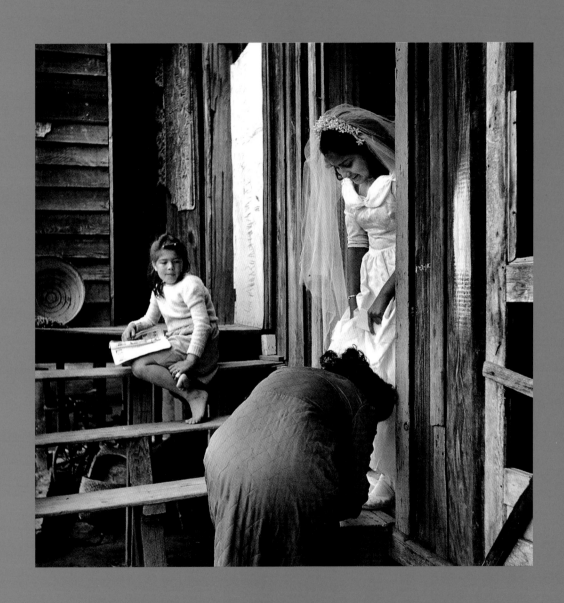

{Left} *Fitting a confirmation dress, Palo Verde.*

{Right} *The banner says, "Oración, The Altar Society, Church of Santo Niño, Los Angeles, California."*

Lou Santillan: Father Thomas was the one who baptized, married, confirmed, and buried in Chávez Ravine. He was Austrian. He learned the lingo. Everyone called him Padre Tomás. He started his sermons, *Queridos hermanos míos y nuestro Señor Jesús Cristo.* He pounded into us, "Don't worry about what people say. Because if you do, you will do nothing." *No se apuren con que el que diran.* Before he went to France, Father Tomás invited me and Father John for a visit. We sat in his office and talked about the old days and about what had happened to the neighborhoods. I guess he sensed that he was going to France to die. That man did sneaky things to help people that even the Archdiocese wasn't aware of. He was like a coyote in a sense, until the Archdiocese caught him and told him not to be doing those things. He housed immigrants there at the church. He said to us, "I want to be called the patron saint of the wetbacks." Then he laughed like a son-of-a-gun.

Kate Provencio: Father Thomas was wonderful, a dedicated priest. He was a saint. We used to give him money, but he never spent it on himself. His suit, supposed to be black, was green-gray, all worn out. And his poor little shoes, all beat up, the poor thing. He never spent money on himself. He was very respected and loved. They formed a committee to try to canonize him.

Trini Hernandez: I saw her once, when I was fourteen, and I decided to marry her. My mother said, "You got to finish high school first, and I did. Sometimes when we talk now we say, "Did you ever think our life would be the way it is now? After Palo Verde and La Loma . . . having the family that we have now. Did you ever think that it would be like this?"

The people there in Palo Verde and Loma were predominantly Mexicans from Mexico. Then we were *born* there, and we are Mexican Americans. Now we have children of all races. We have Germans, Irish, Italians, Jews, Iranians, you name it. A grandson finally married a girl who is part Mexican. Yet we all get along good, and they all have good hearts. I'm very happy with what we have now. Cousins and all, everybody's doing fine. I'm very grateful and thankful to the man upstairs for this beautiful life.

Unknown girl trying on her confirmation dress at home.

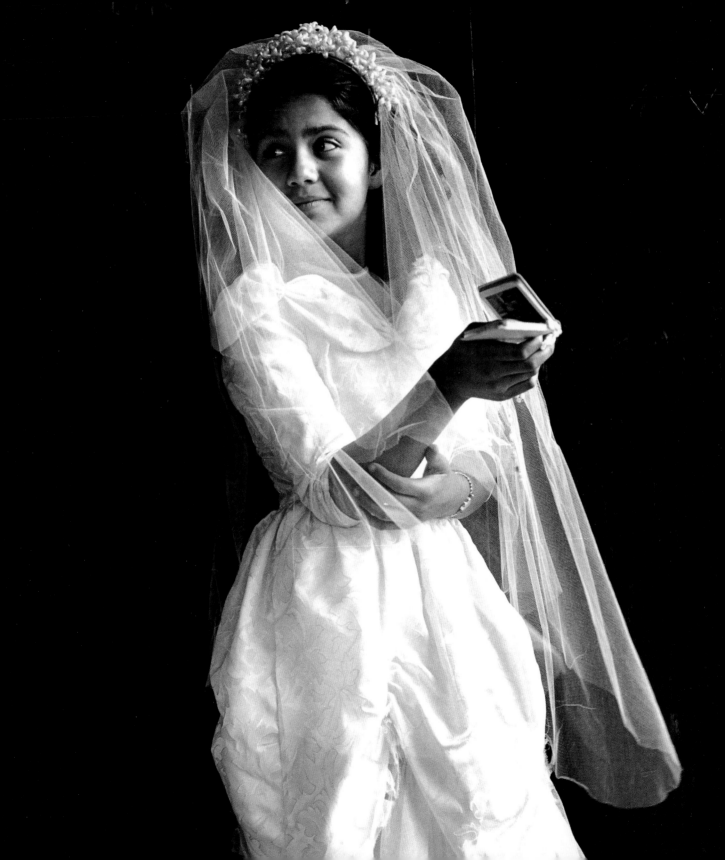

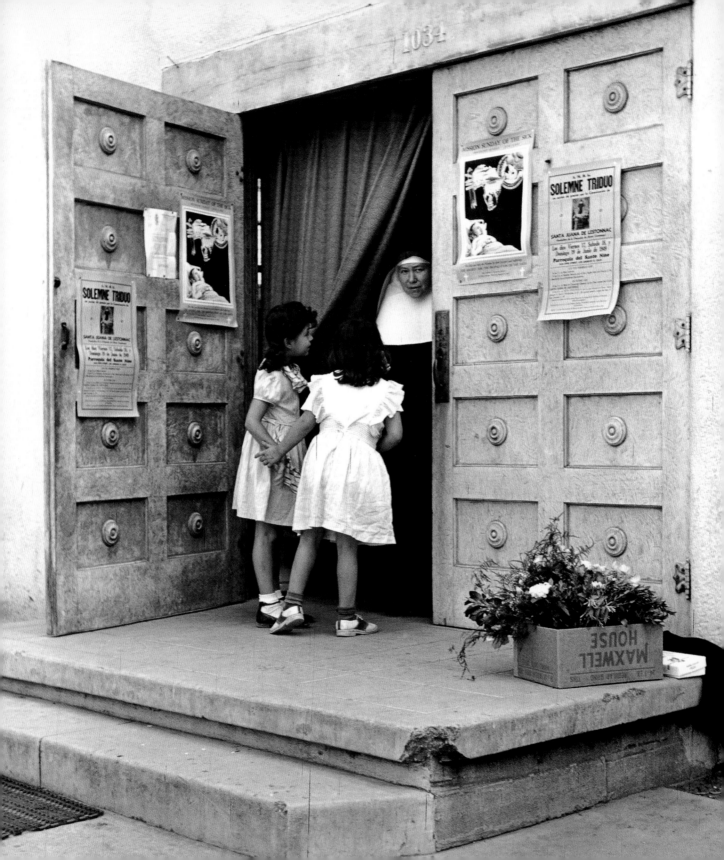

Tony C. Martinez: Oh, I know that Sister. We formed a club, *Los Torzisios.* I used to feel so close to her when I was an altar boy. She had been there for years, I guess. I liked to sit next to her and stuff like that, and when I started growing up, for a while, she used to talk to me. And then one day she walked right past me, and from that day on, after that. . . . Before, she was always so nice to me, and I felt so close to her. The club name, *Los Torzisios*, came from Mexico. During the revolution when they were deprecating the church, a boy named Torzisio stood up for the church and he died. Like a martyr from Mexico. That was Sister Clarita, the little tiny one.

The girls with the powder-blue veils and the white dresses sat in the front rows at Santo Niño. The altar boys faced the priest when he was giving the homily. At that time I was thinking about being a priest. I had been an altar boy for about five years, and was the senior altar boy. I always had the first chair right next to the communion rail. So the girls would sit there, and if I looked around, some girl would always go . . . kiss with her lips, throw a kiss. And I'd bend over quick and say a couple of Hail Marys. I was serious about my religion. I wanted to be a priest. Sundays would go by and the girls would throw those kisses at me. They'd go like that, blowing kisses, and I got to like it. Then I knew that I wasn't made to be a priest. So I said the hell with it. I liked those kisses. So after, I never wanted to be a priest again.

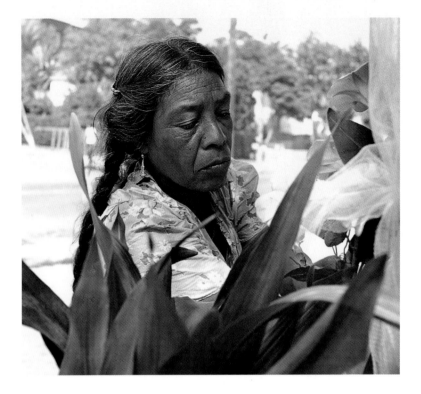

Alicia Arevalo Baca: Juana Chafina. I love her Indian features. I didn't appreciate them when I was little, but now I do. Everyone called her *La Perrera* 'cause she had a lot of dogs. She was a *curandera.* She cured people, healed them. She would treat them.

Albert Elias: She took care of me one time. I got real sick and my mother went to get her, and she said, "Get him up." So they got me out of bed. She spread a lot of newspapers on top of the bedsprings, and then put the mattress back and put me on there. She got a clear glass, filled it with water, and put an egg in the water (I was watching every-thing), and then she put the glass on the floor under the bed. She put candles on each post of the bed (I was craning my neck). She had plants and she waved them in front of me and then put the plants underneath the bed. In the morning she came back, got the glass from under the bed, took the egg out. She held it up and said that the egg had pulled the sickness out of my body, and so now the egg was cooked. She cracked the egg open and it was cooked. I felt better.

Rudy Flores: Everybody tried to outdo each other with their altars. At every house that had an altar, we would stop and pray. We prayed and walked for about two and a half hours. You would pray and kneel and pray and kneel. A good fifteen altars in the neighborhood. They put whatever saint they wanted, mostly the *Virgen de Guadalupe.*

Alicia Arevalo Baca: And look at the *carrito!* We all had them. They'd use the wheels from old wagons or strollers. I'd go down Malvina with Lois, *boy, fast* as could be. We had sticks for brakes to stop them.

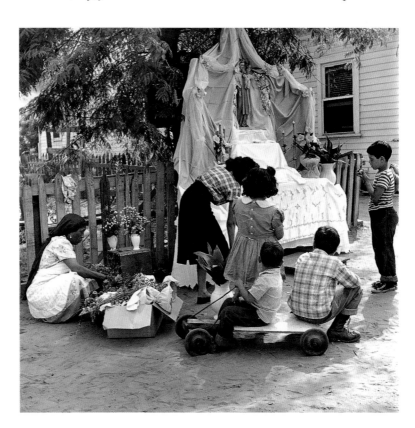

Juana Chafina, left, and Esther De Leon, center, work on a Corpus Christi altar in Palo Verde as neighborhood children watch.

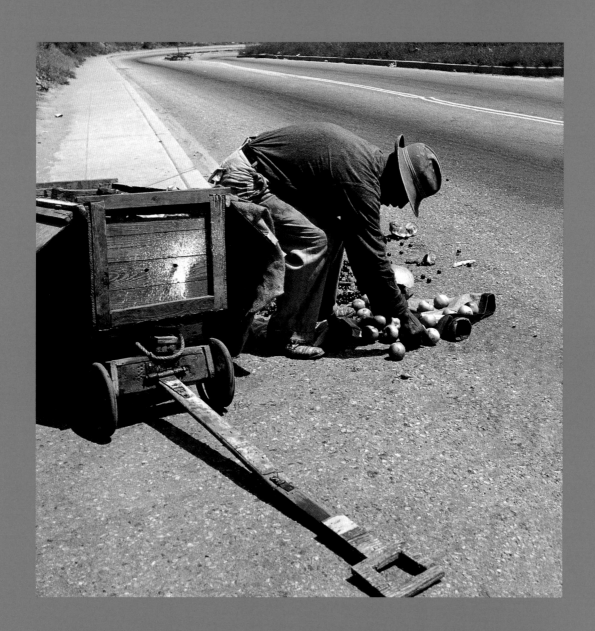

*Mercéd picks up fruit spilled from
his wagon on Bishop Road.*

Alicia Arevalo Baca and Kekito Pacheco:

ALICIA: *Sabes quién es esa? Mercéd!*

KEKITO: *Pobrecito, se le calló su fruta, ay mira!*

ALICIA: Do you remember his cart, Kekito?

KEKITO: *Sí.* One day we took his cart away from him. He got mad. He
never bothered anybody, he just picked up things. He lived next to the
Martinez's with his father.

ALICIA: We called him *Marcé Loco.* He lived on Bishop. He walked down
the main street of Palo Verde. He was always there. Part of the scene.

KEKITO: He was very well known. *Marcé.*

ALICIA: He was teased by the youngsters.

KEKITO: We used to tease him a lot.

ALICIA: We were mean to him. But he was nice and he never bothered
nobody. We used to see him with his wagon and make fun of him. Even
though it wasn't right.

KEKITO: Yeah, kids are mean. We are mean until we learn.

ALICIA: When we all moved out of Palo Verde, I used to say, "Where's
Marcé going to go? What is he gonna do now?" I worried about what
would happen to him.

Geneva Williams: When I came here in 1935 there were only three houses on this entire hill. This street came up from Chávez Ravine Road, or Stadium Way as they call it now. I knew all the neighbors. We organized the Lilac Terrace Improvement Association to get street lights, and such. There were about five hundred dwellings down in the ravine. A lot of them were owned by absentee landlords and were poorly maintained. The common name was "Little Mexico." There were churches, a beauty shop, some little grocery stores, and Palo Verde School, one of the newest schools in the city. They made a lot of movies down there. The one that I recall was *A Medal for Benny.* There was a Dorothy Lamour movie, too. They were always making movies down there.

In 1942 after Pearl Harbor I took the Air Raid Precaution count for the city of Los Angeles. Once I found ten people living in two or three rooms you could hardly call a house. No inside plumbing, no running water, no furniture. That's how bad some of those five hundred homes were. My job was to fill out these cards in case we had to evacuate the city, so I had to have the names and ages of everybody at that address and whether they would need help in vacating the house. So I saw the conditions. There were some very nice homes, but there were several that barely had a roof over their heads.

So, later, I saw some sense to what the housing authority told us they were doing. They were supposed to clear out these substandard houses. They said they were offering fair market value. The landlords sold right away, but there were a lot of hold-outs. Among them there was one woman I will never forget. We had been neighbors and together in the improvement association. She was Italian, married to a French fellow. She was almost crazy she was so angry about losing her home. When I drove by, she would lean on her four-foot chainlink fence and spit at me. I mean there was a lot of real strong feeling about all this. She absolutely hated me because they didn't want my home.

They were going to build apartment houses for low-income families. The people that were being displaced were assured that when this was built they could come back. Well, in the early fifties, there was publicity that they were running out of money and therefore couldn't start this project until another was completed somewhere else. In retrospect,

I always thought that the politicians arranged all this. I could be wrong, but the way things happened, that's how it seemed. Rosalind Wyman and Mayor Poulson were the politicians that were instrumental in getting Walter O'Malley and the Dodgers out here. Some neighbors were saying real unpleasant things about O'Malley, but he would have been a darn fool not to take the proposition the city was offering him. He was given about 340 acres of prime land. It was such a ridiculous deal for the city of Los Angeles. A neighbor and I went house to house with petitions against allowing the Dodgers to build a stadium. But we were just a pebble in the ocean. Even personal friends thought I was crazy for opposing this deal.

Bishop Road went clear out to North Broadway, but those hills are now gone. They spent more than two years hauling those hills away.

We had a grand piano. I would dust it every morning. At lunch my husband would write "Dust Me" on it, with his finger. The dust didn't settle for two years.

Rose Marie Lopez: At Corpus Christi time there were shrines on every street. This one is like when the soldiers were in the war. Mothers used to come to the Virgin and put the flag and pray for them.

Raul Villa, Professor of English and Comparative Literature, Occidental College: The ever-present Virgin, the Mexican flag, the American flag, a Mexican American community. The Virgin, too, is a kind of hybrid, because, based on Spanish religious iconography, she is a mestiza. This altar really represents this community that is between things. Mexican, but not in Mexico. American, not fully, but integrating into the larger society as a working population that supports the upper levels of society. The Virgin brings it together, because she is Indian and Spanish at once. This is a nice symbol of border dwellers, what the communities in Chávez Ravine were.

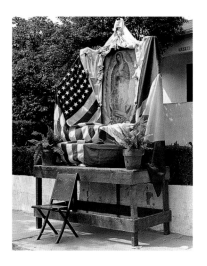

On December 9, 1531, Juan Diego, a Mexican Indian, was on his way to Mass when he heard singing, and on a hilltop saw the Virgin Mary in a cloud of light. She requested that a shrine be built to her for the succor and protection of the people of Mexico. His cloak miraculously emblazoned with the Virgin's image, Juan was able to prove the truth of his vision to the Bishop in Mexico City through a miracle of flowers. The Virgin of Guadalupe has become the supreme Catholic icon of Mexico. In the city of Los Angeles she is depicted in a thousand public murals.

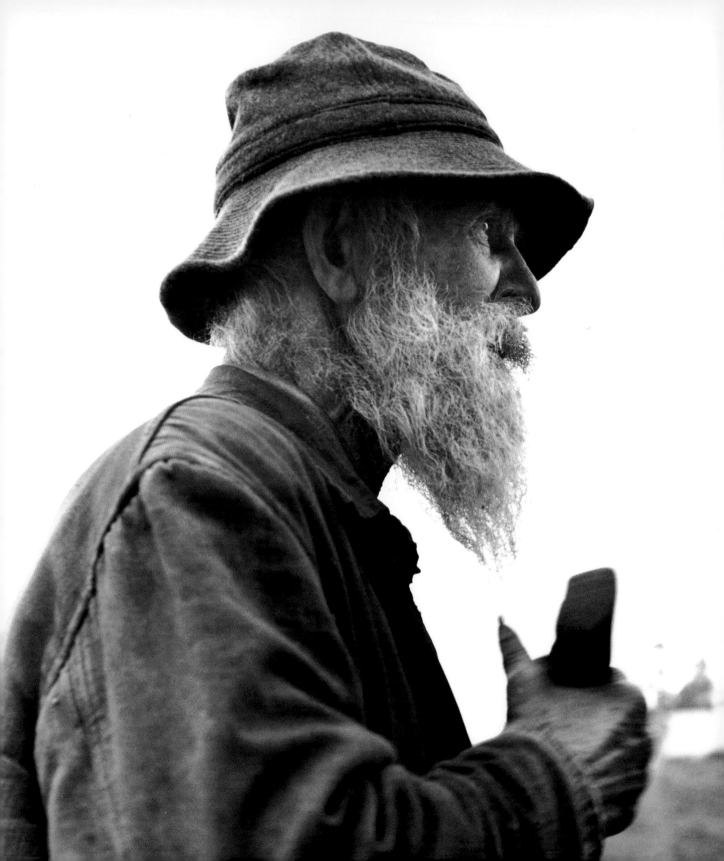

{Right} *On the other side of the hill, an old white bachelor raised his own symbol. This piece of political art said, in part: "Vote for Lord Devil. He is Demo-crazy, and Hell you get it." A little enclave of lone white bachelors lived on one slope of La Loma. They were referred to as* los viejitos, *or* los rusos, *characters who were regarded with some fondness by their Mexican neighbors.*

{Left} *Mr. Wheat, landlord in La Loma.*

Rudy Flores: There's Mr. Wheat! He owned all those shacks. You wouldn't think it to look at him, but he owned half that hill. There were three phones in Loma and one was his. I used to pay him a nickel to use his phone. He had it locked up. He'd open it and dial the number to call my girlfriend—my wife, now. This month we have fifty years together. We just came back from celebrating in New York City.

Kate Provencio: He'd pick you up if you were walking. He'd go out of his way for anyone. He was a very nice man.

Lalo Alvarado: He had an old Buick, a touring car, but topless. He used to take some of the families from La Loma to Moorpark to pick *chabacanes,* apricots, in season. He would pick up two or three families in his old Buick and take them all. And bring them back home. He was a good old man with his old Buick.

Murphy Hernandez: Mr. Wheat was deaf. I could hear him talking clear down on Amador, "WHAAT?"

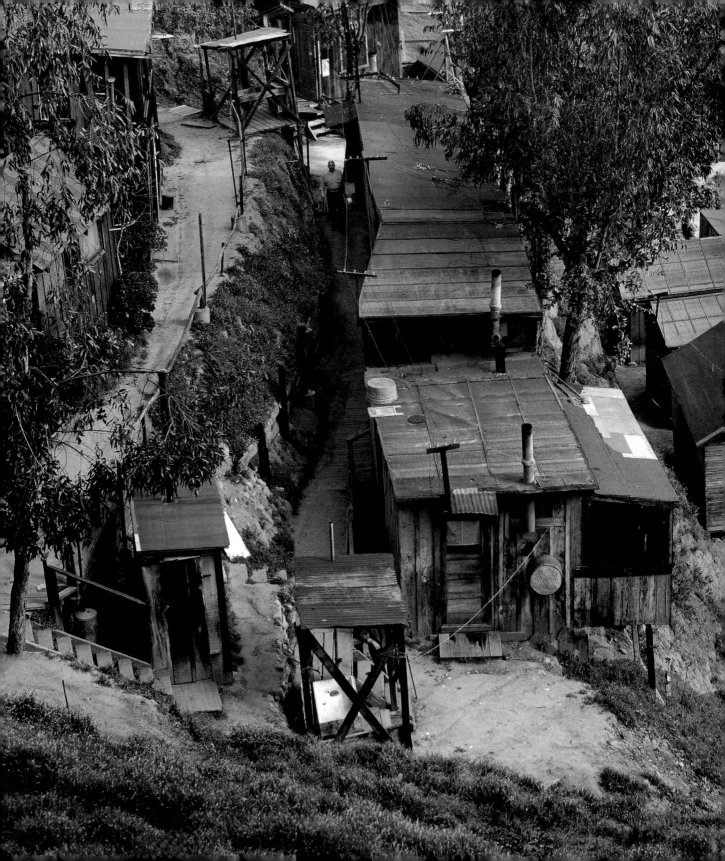

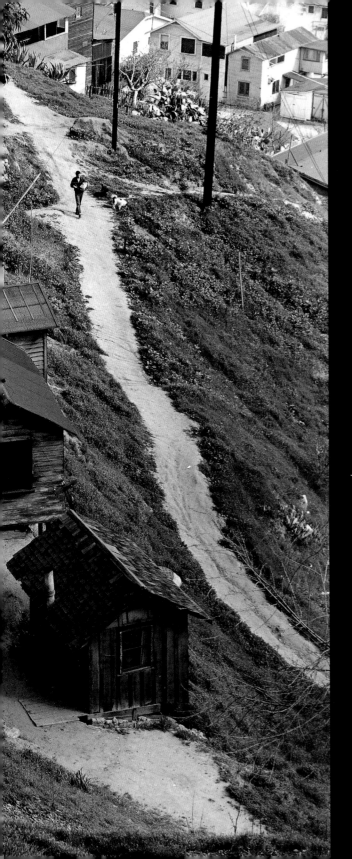

These are some of the rental shacks
occupied by the white bachelors,
los viejitos. *The dirt path at right
was shown on city maps as
Phoenix Street. Some of these men
had worked for the railroad, some
found work as movie extras.
One, with flowing white beard
and hair, was a champion Santa
Claus in season. Those who
did kindnesses to the Mexicans
are remembered, as I recall those
individuals who made me welcome
in their little group. But mostly
they are simply gone, leaving only
us strangers, not kin, with their
memory. They are, by contrast, a
reminder of how tied together
the Mexican American community
is, by marriage and bloodlines,
through time and across borders,
by language and culture and
history, and most strongly, by a
tradition of caring.*

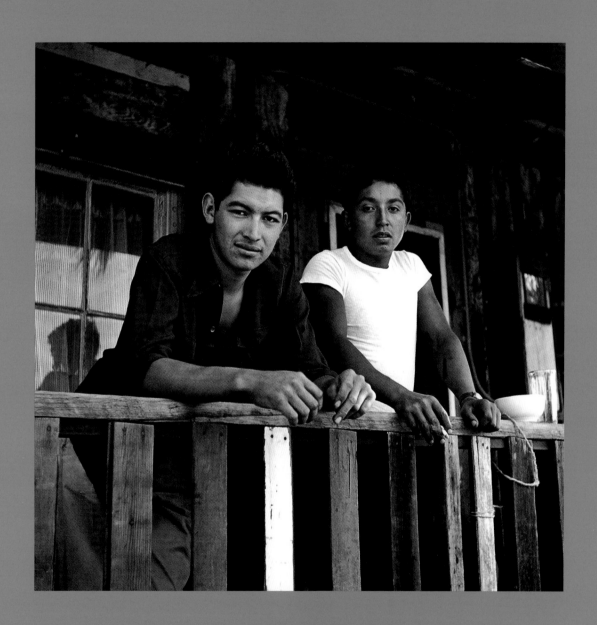

Gilbert and Tepi Hernandez:

GILBERT: I remember you taking this picture. Black and I were on the
porch at Brooks Avenue and Effie. When you took that picture in '48,
I was already married with Tepi. We have been married fifty-three years
now. My two daughters were born right here in this house.

TEPI: I remember when we sat on that porch. I taught Stella how to walk
there on that porch.

GILBERT: I have a picture of my daughters sitting right here. I took their
picture on the steps.

TEPI: But I was so happy to be out of there.

GILBERT: I was happy there because it was like a . . .

TEPI: There were a lot of burglars there.

GILBERT: No.

TEPI: Yes.

GILBERT: It was like a ranch, a place real open.

TEPI: I don't care, but there were thieves.

John Rivera: I used to shine my shoes. I guess I still do, once in a while. Now that I don't have a wife to remind me, I don't as much. I don't have to. She would say, "Where are you going? Well, then, shine your shoes." She's been gone two years now.

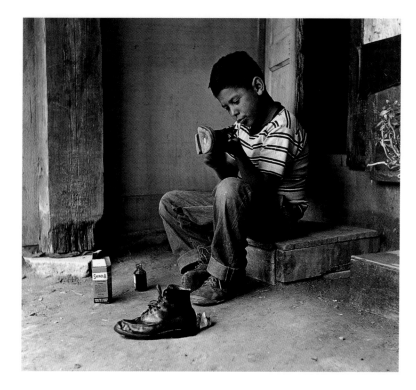

{Left} Lost in concentration, a young man shines his shoes for church.

{Right} Perfita is remembered as a vibrant soul.

Gilbert Hernandez: Perfita had a little cap and she smoked her cigar and walked all the way to Genaro's store every day. She wobbled when she walked. She had a cane, she greeted everyone, and that's Perfita.

Rudy Flores: She knew everything that was going on in our neighborhood. She was the one that would say, "Man! You guys sang all night. It's alright, I like the way you sing, but on Sunday night? People have to go to work on Mondays!"

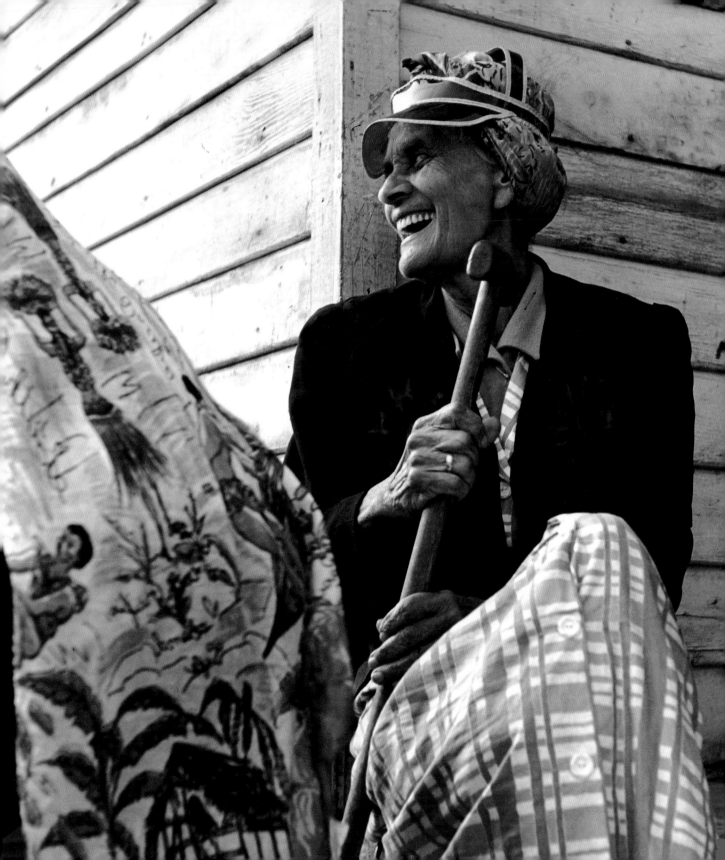

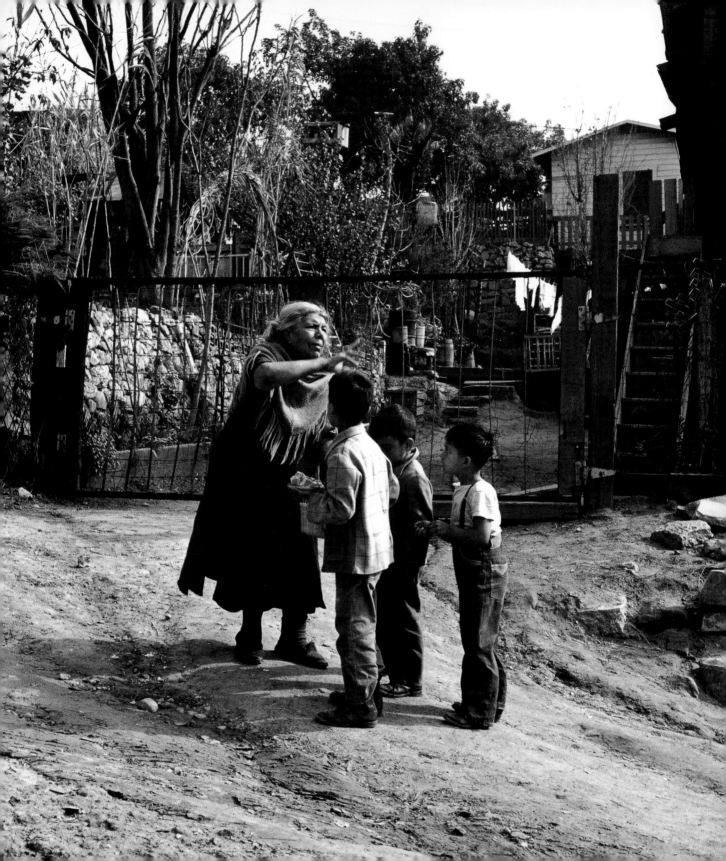

Maria Garcia directs boys to deliver a bowl of freshly made squash-blossom candy.

Sally Anchondo: My grandfather built a little bench right here in front of his house. The mothers used to sit there and crochet and darn and talk. After they'd put away their work and gone inside, we'd say to my grandmother, "Grandma, tell us a scary story."

"You go home and do your homework, do your chores, and then come back and I will tell you stories." Her name was Maria Garcia. She would tell us really scary stories.

Then we'd say, "No! No! Don't tell us any more!" We would get too scared. She told us stories about *La Llorona* and all that, old stories from México. She was very well liked in that neighborhood.

On July 15, 1988, Natalie Ramirez mailed the following letter.

TO: Vin Scully, KTTV and the Whole Dodger Organization

Last night, July 14, 1988, I watched your special on the 30th Anniversary of the Dodgers and KTTV, and I must tell you it made me very angry! This is not the first time that Chávez Ravine has been referred to as a dump or a wasteland. I want to let you know at the start that I am a very big fan of the Dodgers and Vin Scully, but how dare any of you call Chávez Ravine a wasteland or a dump. Every time anyone talks about Chávez Ravine before the Dodgers came along they seem to forget that many families made their homes there! No one wants to acknowledge the fact that people lived there. Maybe it wasn't Beverly Hills, but it was home to a lot of people, my family included. Doesn't anyone want to acknowledge us because we are Mexicans? Or is it because we were told that our homes would be destroyed to make room for low rent housing? Alright, the people have all moved away and all the houses are gone. But please don't keep referring to it as a dump or wasteland. The people all loved their homes. Once a year the people who once lived in Chávez Ravine all get together for a picnic at Elysian playground, right next to Dodger Stadium. They could let you know when the next picnic will take place and you could come around to meet the people whose home you call a wasteland.

Reyes Guerra: We were having breakfast, listening to some big band music on the radio, when the music stopped and it said, "We interrupt this program for an important announcement. The Japanese are bombing Pearl Harbor."

My father threw his hands up. He said, "I *knew* there was going to be a war."

My mother looked around at my brothers. She just looked at them. She got up from the table, went out, and sat on the porch. My father goes out there and I go out there and my mother is crying. My father says, "What are you crying about?"

She said, "I'm not crying." Her eyes full of tears. 'Cause she knew my brothers were going to go. So everybody started getting drafted. I remember two guys that died in the war. One Italian guy in the navy from a very nice family. The other was in the marines. Everybody bought a flag and you put stars on it. If there were four stars it meant four were in the service. Almost everybody in the neighborhood was joining the marines. Some were getting drafted into the army.

I remember when my brother Tachito got home. It was about one o'clock in the morning and my mother was saying, *Es Tachito, es Tachito.* We all got up. My brother is standing there in his uniform with his duffle bag. He puts it down, everybody was hugging him. He was home.

Then everybody was coming home, and my brother was asking, "What about this guy?"

"Oh, he got killed." Or, "He was missing in action."

When the war was over, my mother started visiting those mothers who had lost a son in the service. There was a lot of participation during the war in the church. There were parades. When the war ended there was a big celebration. It was a *neighborhood.* In a few years I started hearing they were going to build projects here. People started selling, but I didn't understand why. The city came and they'd say, "Either take this money now or we're going to take your house anyway. You're going to lose anyway."

"Dumb Mexicans" is how they had them figured.

Charolito has the ball, Fernando Chavira runs right, and QTP, in the foreground, looks for the long pass. The black tank beside the central telephone pole was the stage for early morning guitar serenades of the neighborhood. For Mike Vasquez this scene represents a moment frozen in mind. Touching a patch of bare ground at the right of the photo he said, "I was rolling dice right here when I heard the news that Japan had bombed Pearl Harbor."

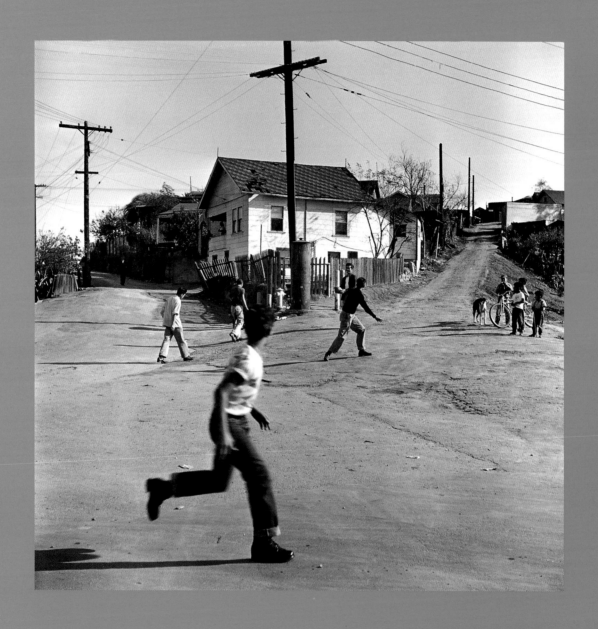

A few people seemed to be known to everyone, but there are those whose names are yet to be found. There have been guesses, mistaken identities, look-alikes. Often a kind of mental thrashing about occurred, stirring the deepest pools of memory. And sometimes resolution was slow to settle, as in the following exchange between Alicia Arevalo Baca, who spoke first, and her lifelong friend Kekito Pacheco.

Es tu tía, no? Abrana?

No, that is not my *tía.*

Oh, that is not your *tía Abrana?*

No, my *tía* never wore that.

Oh, I see, that is not your *tía.*

No, that is not her. Oh, who is that?

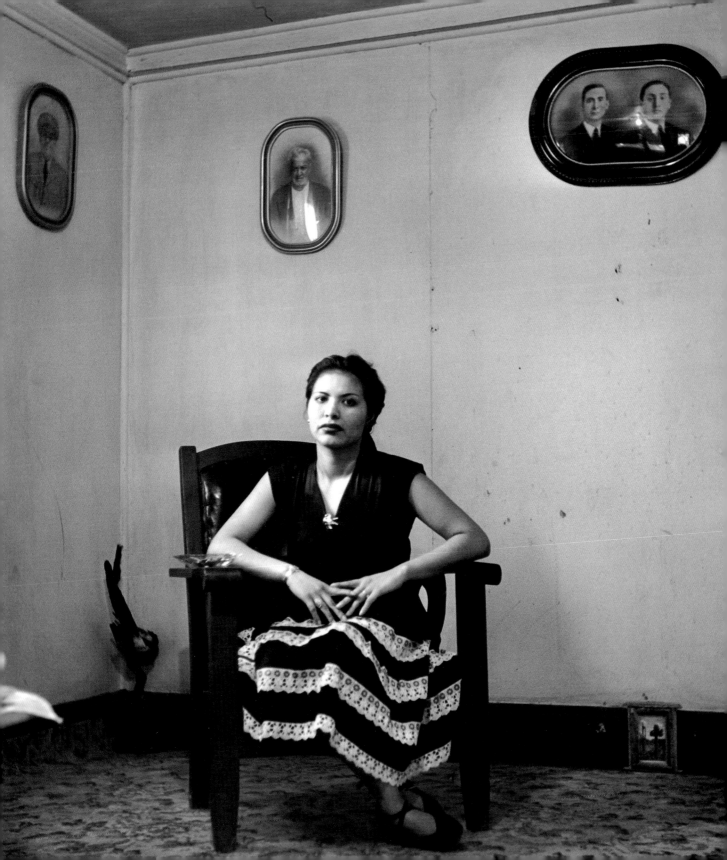

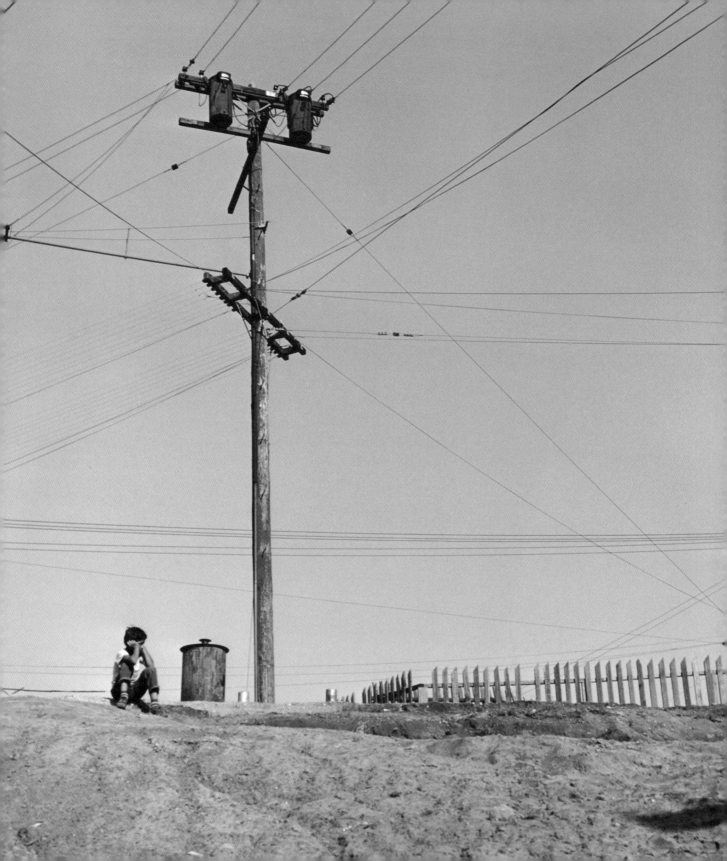

Zeke Contreras: The houses were still there, but weeds were growing. Everything was left neglected and abandoned. They still hadn't started bulldozing. They wanted to acquire all the land before they started demolishing. They were wrecking some houses below, but a lot of the houses were still in place. By then we had most of Chávez Ravine to ourselves. But it was kinda lonely then. Us and the coyotes.

Blank sky and bare dirt—
La Loma near the end.

Rudy Flores: In Mexico, Lefty Rosales's father had a burro and he delivered milk to my mom's folks. And they both wound up living here in Palo Verde. Their grandfather saved my dad's life one time during the revolution. He was with Zapata, and the Federal troops had him on the run and he hid on their ranch. In Chávez Ravine in the neighborhoods, there were people from both sides who had come over to the U.S. People who were with Villa and people who were running from Villa. My mother said that the priests were all hiding. The priest from our town, we fed him and hid him, she said. Villa's guys would bring the saints out of the church, put them against the wall, the priest would be standing there, and "Bang!" they would blow these plaster saints away. Unbelievable things they did. My dad said that Villa told the Mexican Indians, "Follow me. We are going to fight these rich people. We have to get rid of all of them landlords."

I knew the room I was born in. My mom said, "You were born in that corner." We didn't come out of the neighborhood sometimes for two or three months. When you did go out, it was weekends. You'd wear your Sunday's best and walk down there and meet people. Go see the shows. It was when the jitterbug was in. The *pachucos.* The war. Felix Agoura, Sammy Tellas, Henry Rivas, and a guy we called Nene. God takes the good ones, you know, like Nene, who was an altar boy, or Felix, all he liked was to dance. Everybody called you by your last name. Like the Hernandez family, the Rivas family. So and so is fighting with the Lopez family guys.

Once you start selling, it breaks the chain. People heard thousands. All they wanted was the land; the houses they'd bid $35, $50. Maybe they wanted the bricks, the windows, the doors. You took what you wanted and leave the rest. People from all over used to come and bid $15, $25, $50. A lot of people were still living there. They didn't want to leave.

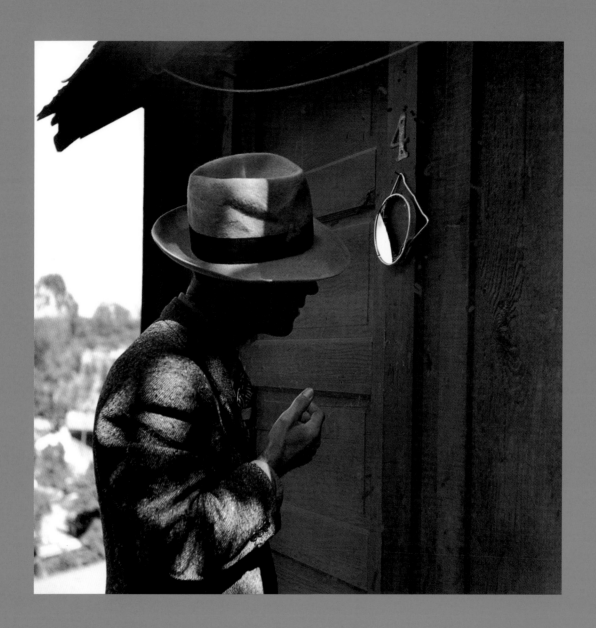

They were knocking them down every day. People would take every-
thing, the lighting, the doors, and bricks by the truck loads. They had
those auctions every Saturday. First they knocked the houses down.
Then they moved all the dirt, starting from Effie. Only two streets in or
out of that neighborhood. They go to work every morning and come
home every afternoon and you see them. "Here comes Lalo, here comes
Tule." They'd all stop in the store before they got home and have a beer
and talk about their jobs and what's going on with their kids and all that.
Bulldozers came in the night. Huge dump trucks to pick up the dirt. Two
of them at one time knocking down the hill and flattening it. They came
down Bishop Road to Broadway, and they had some guy down there with
flags and lights to stop the traffic. They went from nine o'clock at night
until four in the morning. And them trucks worked like a merry-go-
round. When they'd be coming up it was so steep that they'd use two
tractors. Trucks'd go like the bat out of hell.

What the people were mad about more was the way they went about
it. First they wanted to build projects, and we'd get first choice. Then
they said an airport. Roybal was our councilman. He would come and tell
us one thing and then go down and tell them another. My grandmother
had cancer and she spent a lot of time in General Hospital. I was a kid
and I used to cry. She would be there once a month, like the army. She
didn't speak English and cried. I would say, "Let's take her home," and
they would threaten us, "You can take her home, but don't bring her
back." We used to bring her home. The point is, when my people sold,
the county got their money from the house. If you owed the county, what-
ever money you got for your house, they got it. They paid us $5,000.
The county hospital took $2,000.

View toward Elysian Park from the place of the viejitos. The homes on Amador and Solano Streets below still stand. Lalo and Socorro Alvarado found a home there, at the shortest possible remove from the destruction of La Loma. Socorro said, "At night sometimes we hear coyotes yipping up there now. That sets off all the dogs in the neighborhood barking. We hear owls, too. Sometimes we hear owls up there in the old place."

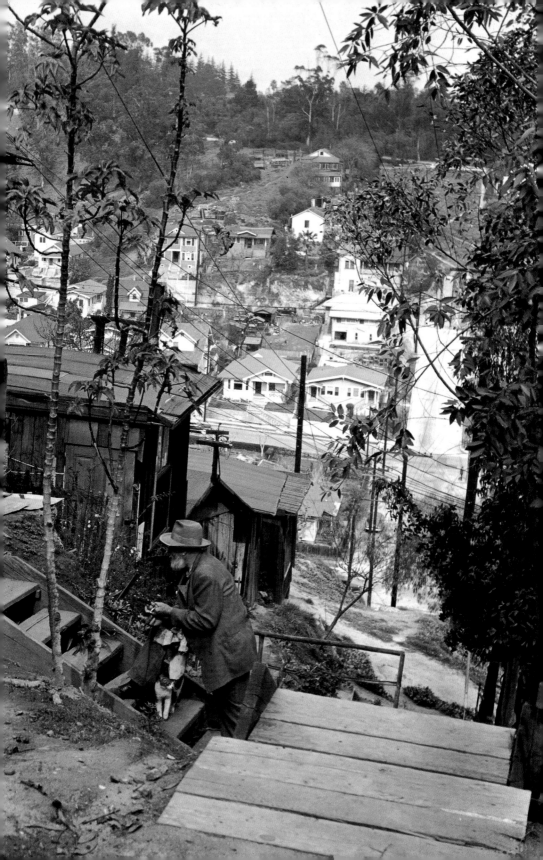

Eulalio (Lalo) and Socorro (Cora) Alvarado:

One rainy afternoon Lalo and Cora Alvarado were looking at the photographs spread out on their dining room table. Framed rows of the faces of children and grandchildren, most of them photographed in cap and gown, watched from the sideboard behind them. From her corner by the stair, the Virgin of Guadalupe blessed us all. I wanted to film this scene and asked permission. They assented, and I left the house to get my equipment from the car. I later discovered that I had forgotten to turn off my tape recorder. Playing the tape back later, I heard the following exchange.

ME: I am going to get my camera now. Can you stop looking at the pictures for a little bit until I come back with the equipment?

LALO: Alright.

Sound of the door opening and closing, then a moment of silence until the voices begin. They had known each other since she was four years old and he nine. He remembers that her hair was almost as long as she was. Now she was eighty and he eighty-five. They had been married for sixty-two years.

CORA: Here's Amador. *Mira! Este es Amador, la casa de Tachita, la casa de Granado,* this is La Loma. *Aquí era adonde yo vivía, y aquí está de los Piños.*

LALO: I do not know. It's all dirt roads. *Allí adonde estaban fríos* when you were older?"

CORA: *Sí, aquí.* This is terrible how they came to disrupt our neighborhood. It was such a nice little village.

LALO: Let me see.

CORA: *Y acá está donde vivía Doña María, y el camino pa'rriba. Doña María la India, te acuerdas? Qué bonito. Qué bonito estaba Palo Verde, Chihuahua! No sé porqué lo tumbaron.* Oh look, I have not noticed that, how pretty.

LALO: He changed.

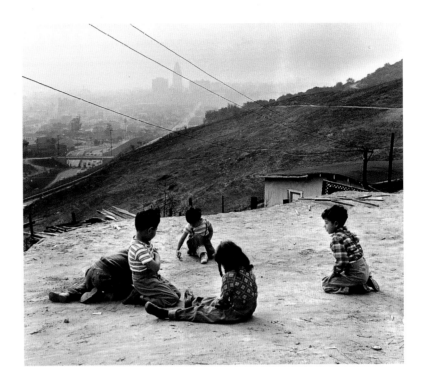

Little Albert Gonzales, Patsy, and Choti at the right, playing on a newly prepared home site.

CORA: You got stuck with that picture, didn't you? Does it bring back memories? Oh, the stairway. That is still there, *verdad.* Look, *le salió la casa esta, mira, nada más.* Oh, I wish I was back there again. We are living our youth days.

LALO: Don't mess them up.

CORA: I am not messing them up. I am handling them with care.

LALO: Where is Delia's house?

CORA: Delia? Delia's house is right there. That is Delia's house, right across from Mrs. Lynn's. *Quién seran estos niños, tan bonitos?* Why can't kids play like this now. Look at how cute they played. Playing marbles.

Sound of door opening.

ME: You were supposed to stop looking.

Laughter.

Academy Drive, 81

Adame, Atilano, 82

Adams, Clinton, 43

Agoura, Felix, 133

Aguilar, Delia, 31

Aguilar, Felipe, 31

Alexander, Robert, 18

Alvarado, Eulalio (Lalo), 46, 65, 82, 119, 136, 138, 139

Alvarado, Juan, 88

Alvarado, Louis, 66, 82

Alvarado, Socorro (Cora), 46, 136, 138, 139

Amador Street, 119, 136, 138

Anchondo, Sally, 24, 34, 41, 42, 46, 65, 127

Arechiga, Abrana, 41, 130

Arevalo Baca, Alicia, 12, 23, 78, 112, 113, 115, 130

Arizmendi, Baby, 82

Arroyo Seco Freeway, 82

Avadon Bar, 73

Ayala, Martina, 70

Aztlán, 50

Bantacorte, Francisca, 65

Barreres, Patricia (Punky), 21

Bernal, Lou, 82

Bishop, 31, 88, 91, 104, 115

Bishop playground, 86

Bishop Road, 11, 12, 38, 73, 115, 117, 135

Bonda, Manuel, 86

Brooks Avenue, 34, 37, 46, 123

Ceballos, Joe, 12-13

Cervantes, Candelaria (Chacha), 103

Cervantes, Eleanor (Cano), 70, 103, 104

Cervantes, Pete (Catos), 103

Chafina, Juana, 112, 113

Chávez, Carlos, 82

Chávez, César, 53

Chávez Ravine Road, 116

Chavira, Fernando, 128

Community Service Organization (CSO), 53

Contreras, Zeke, 38, 82, 133

Cruz, Henry, 27, 81, 87, 93

Curandera, 74, 112

Dagenpatt, Dickie, 102

Davidson Brick Company, 34

Davis Street, 34, 104

Dead End, 94

De Leon, Esther, 50, 113

Delgado, Vince, 85

Deputy Auxiliary Police Club, 101

Dodger Stadium, 17, 21, 23, 34, 38, 76, 81, 127

Dodgers, 21, 41, 43, 117, 127

Duran, Maria, 53

Effie Street, 34, 38, 42, 123, 135

Elias, Albert (Beto Calavera), 32, 33, 54, 62, 76, 96, 102, 112

Elysian Park, 12, 17, 28, 32, 38, 75, 91, 111, 136

Elysian Park Heights, 18

Elysian playground, 127

Father Thomas (Tomás), 37, 75, 107
Fernandez, Lola, 17
Flores, Rudy, 57, 113, 119, 124, 133
Frias, Tony, 102

Gabriel Avenue, 32, 82
Garcia, Maria, 127
Gaten, Angel, 102
Gonzalez, Albert, 139
Gonzalez, Julie, 101
Gonzalez, Julio, 101, 102
Gonzalez, Steven, 101
Guerra, Reyes, 27, 70, 88, 128
Guerra, Tachito, 128

Hernandez, Bruno, 34
Hernandez, Candelario, 37
Hernandez, Domingo, 37
Hernandez, Gilbert, 34, 43, 123, 124
Hernandez, Marciano (Murphy), 24, 49, 54, 70, 94, 119
Hernandez, Tia Natalia, 37
Hernandez, Nina, 70
Hernandez, Tepi, 37, 88, 123
Hernandez, Therese, 54
Hernandez, Trini, 62, 108
Hines, Thomas, 18
Housing Authority of the City of Los Angeles, 18, 21

Jacquez, Carol, 50
Jimenez, Ruben, 82
Johnson, Elinor, 104
Johnson, Johnny, 31, 66, 104

Kelly, Mary Madrid, 34

La Loma, 6, 9, 11, 12, 28, 31, 34, 42, 43, 44, 54, 57, 58, 65, 66, 73, 78, 82, 85, 86, 91, 108, 119, 130, 136, 138
Lange, Dorothea, 14
Lilac Terrace Improvement Association, 116
Lincoln Heights, 33, 37
Lincoln Heights jail, 96
Lopez, Rose Marie, 62, 65, 117
Los Angeles, pueblo, 12, downtown, 17
Los Angeles, City of, 21
Los Angeles City Council, 18, 21
Los Angeles City Hall, 9
Los Angeles City Jail, 17
Los Angeles County Museum, 14
Los Angeles Planning Commission, 18
Los Angeles Times, 23
Los Desterrados, 17, 102
Los Torzisios, 111
Los viejitos, 119, 121, 136
Loya, Lupe, 44

Madrid, Connie, 57, 58
Madrid, Gilbert, 58, 66, 70, 82, 96
Madrid, Iladro, 57, 62
Maldonado, Victor (Tarzan, Racoon), 103
Malvina [St.], 34, 113
Martinez, Dickie, 102
Martinez, Rose, 57
Martinez, Tony C., 65, 77, 111
Merced, 115
Montalban, Ricardo, 102
Montez, Tony, 42
Mora, Mr., 65
Moti, 93
Moyer, Sylvia, 44
Muñoz, Luis, 42
Muñoz, Manuel[ito], 78, 101
Muñoz, Sally, 57, 62, 78
Muñoz, Sara (Sarita), 57, 78

Narvarez, Julia, 103
Narvarez, Margaret, 103
Narvarez, Mary Hilda, 103
Neutra, Richard, 18
North Broadway, 117, 135
Novoa, Nestor, 102

O'Malley, Walter, 21, 41, 117
Ortega, Luis, 91
Ortiz Lopez, Connie, 73
Ortiz Provencio, Catalina (Kate), 73, 77, 107, 119

Pacheco, Kekito, 115, 130
Pachucos, 12, 50, 70, 133
Paducah Street, 34, 82
Paducah Street School, 77
Palo Verde, 12, 28, 32, 34, 38, 50, 53, 73, 85, 86, 91,
 101, 107, 108, 113, 115, 133, 138
Palo Verde Elementary School, 38, 73, 76, 77, 78,
 103, 111, 116
Pasadena Freeway, 9, 11
Perfita, 124
Perich, Leo, 87, 91, 94
Phoenix Street, 74, 121
Pine Street, 34
Pinedo-Bye, Virginia, 111
Police Academy, 101
Poulson, Norris, Mayor, 17, 21, 117
Praeger, Arnold, 21

Ramirez, Bernardo, 37, 49
Ramirez, Genaro (Jerry), 91, 94, 124
Ramirez, Natalie, 127
Ramirez family store, 91, 94, 124
Reposa [St.], 34, 82
Rivas, Henry (Kiko), 87, 94, 133
Rivera, John, 49, 124
Rosales, Gilbert, 70
Rosales, Lefty, 133
Rosales, Tony, 94
Ross, Fred, 53
Roybal, Congressman Edward R., 53, 135
Rumble, Bill, 53

San Conrado Church, 103
Sanchez, Frank, 23, 49, 66, 86, 87
Santillan, Father John, 23, 102, 107
Santillan, Lou, 41, 102, 107
Santo Niño Church, 28, 34, 75, 107, 111
Santos, Black, 123
Sister Catalina, 50
Sister Clarita, 50
Solano Avenue, 6, 28, 81, 136
Solano [Avenue] School, 28, 86, 103
Spruce Avenue, 34
Stadium Way, 34, 82, 116

Tellas, Sammy, 133
Tomasito, Don, 81
Torres, Espy, 75
Torres Roldan, Carmen, 28

Urrutia, Pete, 91

Vasquez, Helen, 69
Vasquez, John, 94
Vasquez, Mike, 65, 69, 81, 128
Villa, Raul, 117
Virgen de Guadalupe, 113, 117, 138

Weston, Edward, 14, 15
Wheat, Mr., 119
White, Minor, 14, 15
Williams, Geneva, 116
Wyman, Rosalind, 117

Yolo Drive, 34, 65, 81

Zerafin's Store, 73

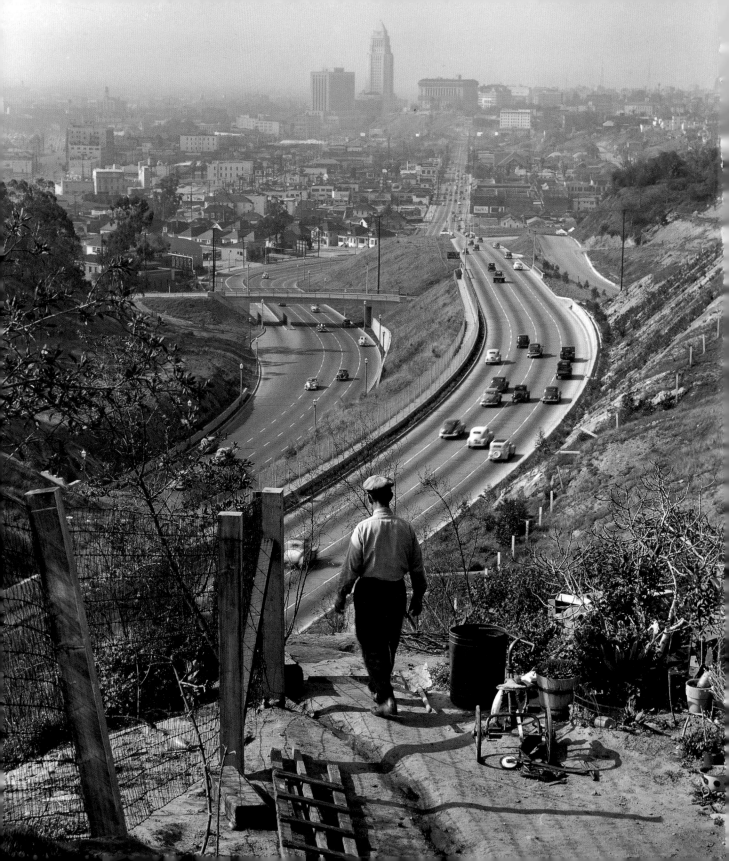

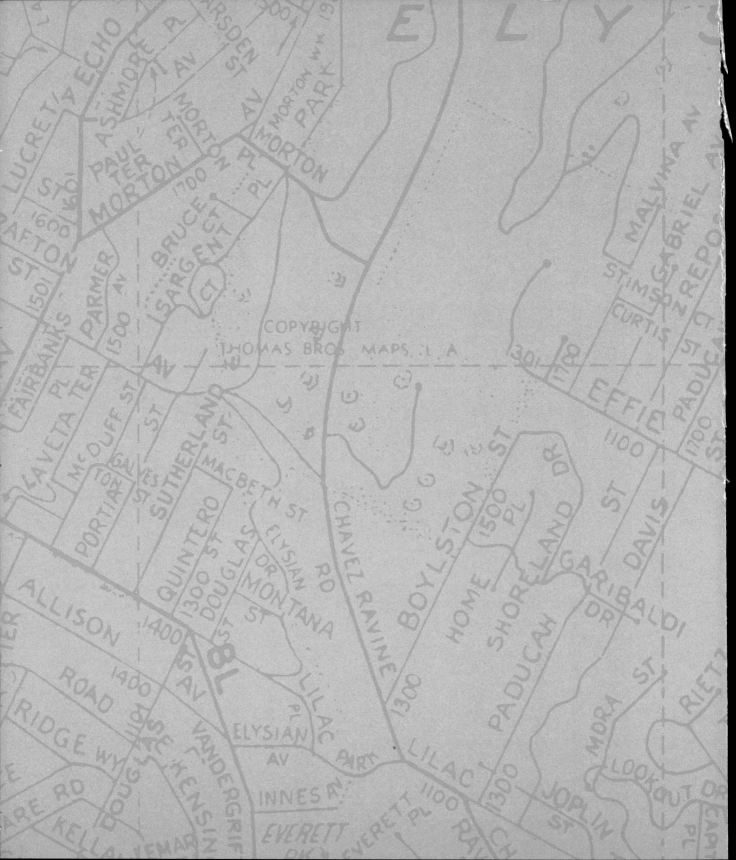